AN ARTIST AT WAR

THE WWII MEMORIES
OF *STARS & STRIPES* ARTIST
ED VEBELL

ED VEBELL **AN**
ARTIST
AT
WAR

4880 Lower Valley Road • Atglen, PA 19310

Book and cover designed by RoS
Type set in Warnock Pro

ISBN: 978-0-7643-5314-7
Printed in Hong Kong

Published by Schiffer Publishing, Ltd.
4880 Lower Valley Road
Atglen, PA 19310
Phone: (610) 593-1777; Fax: (610) 593-2002
E-mail: Info@schifferbooks.com

For our complete selection of fine books on this and related subjects, please visit our website at wwwschifferbooks.com. You may also write for a free catalog.

This book may be purchased from the publisher. Please try your bookstore first.

We are always looking for people to write books on new and related subjects. If you have an idea for a book, please contact us at proposals@schifferbooks.com.

Schiffer Publishing's titles are available at special discounts for bulk purchases for sales promotions or premiums. Special editions, including personalized covers, corporate imprints, and excerpts can be created in large quantities for special needs. For more information, contact the publisher.

CONTENTS

4. THE WAR'S END

5. HOME AGAIN

INTRODUCTION

My number came up and I entered the US Army Air Force and started my military journey with the first stop: Atlantic City, New Jersey, where the Air Force had requisitioned all the large hotels on the boardwalk for lodging and foot drills. After one week of marching up and down the boardwalk, singing patriotic Air Force songs, my name was suddenly called out. After reporting to the commanding officer, I was allotted some cash for food and a train ticket, and was told to report to MacDill Air Field near Tampa, Florida. I didn't know until I arrived at MacDill that I had been transferred to a camouflage engineering unit attached to the Air Force. It finally dawned on me that when my name was given to the War Department my occupation as a professional artist was attached to my name. And of course, the military tends to associate professional artists with the art of camouflage, of which I knew nothing. When I arrived at the 904th Camouflage Engineering unit, they had already completed their basic training, were all packed, and were about to be immediately shipped overseas. I complained that I hadn't received any training at all. The response was, "You don't need any training, you are going to be an artist." Not very reassuring!

Sure enough, within days we were sent with all our equipment to Ft. Dix, New Jersey. While waiting to be shipped out, I decided and proposed marriage by phone to Virginia Kaminski back in Cleveland, Ohio. The plan was for her to come and meet me in the town of Fort Dix to discuss plans for the marriage. Her mother was to come, and they would arrange a small wedding. After I got back to the barracks there was a clamp down on all military leave and phone calls. We were about to board a troop ship by 0600 the following morning. I had no way to contact her that we were being shipped out, and would be on our way to Europe. She and her mother were literally left waiting at the church for me to show up and complete the ceremony. She didn't receive an explanatory letter about what happened from me for the next two months. She waited six years for me to come back. She finally gave up, got married, and had two children, a boy and a girl. The girl I met some eighteen years later was about to join the troupe of the New York City Ballet. She was a stunning beauty, but extremely shy, and never said a word during a lunch with her mother and me.

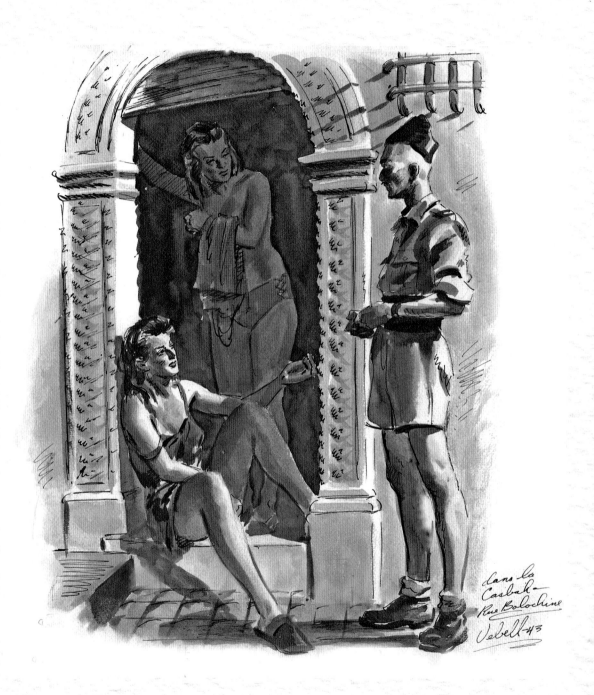

French colonial soldier haggling for a better price from a prostitute on the Rue Balochine in the native Casbah of Algiers, North Africa. The Casbah was "off limits" to all except French military, but as an artist I felt compelled to ignore the rule. 1943.

1

NORTH AFRICA

Convoy to Casablanca

We boarded our troopship at 0600 that fateful morning like thousands of other young men, bound for the unknown. With being stacked in improvised bunkbeds like cordwood, one on top of each other, four deep, it made for an unforgettable experience. The first day or two was spent below deck in the stifling heat and dimly lit bowels of the troopship. Finally, we were allowed to go topside, and I never forgot the shock of seeing the blinding light of the emerald green ocean for the first time. The sight of the accompanying convoy of ships stretched to the horizon. We landed in Casablanca, North Africa after two weeks at sea, just following the initial Allied invasion.

My first impression of Casablanca was startling from the deck of our troopship. The city shoreline was so modern, with gleaming white buildings and balconies overlooking the sea. Unfortunately, it was contrasted with abject poverty, with the Arabs living in ramshackle huts with corrugated tin roofs in the fields behind the city. We pitched our two-man tents in the same dry fields along with scores of camels wandering about, relieving themselves all over the landscape. Stepping carefully was of paramount importance.

After two weeks in Casablanca, we packed our gear in the famous leftover French freight cars called "40 and 8s" from the World War I era ("*quarante hommes ou huite chevaux*")—they had the capacity for forty men or eight horses. With the floors covered in straw for sleeping, we headed due east, skirting the edge of the hot Moroccan desert, then tunneling through the Atlas Mountains for the city of Oran. The freight car doors were left open to counter the heat. An Arab chieftain suddenly appeared, riding in from the adjacent desert on a magnificent white stallion and brandishing a rifle. He proceeded to pull up alongside our train, to challenge us to a race, which brought on encouraging cheers from the young GIs lining the wide open freight doors. The race only lasted a few minutes, followed by the chieftan raising his rifle in salute and veering away to disappear in the desolate sand dunes. A memorable sight!

Eventually the puffing engine brought us to the long dark tunnels cutting through the Atlas Mountains. Most of us had stripped off our hot military shirts and climbed

on top of the roofs of the freight cars to escape the heat. But forgetting about the extremely low height of the mountain tunnels roofing and coming upon the tunnels suddenly with no time to climb below, we had to flatten ourselves to the extreme to keep from being scraped off the roof. All the while the smoke stack of the ancient locomotive was belching and filling the tunnel with a choking black, nauseous smoke—plus emitting cascades of bouncing red-hot embers off of our prone exposed GI bodies. Our only recourse was to cover our faces with our handkerchiefs, and hope for a quick exit from the tunnel.

Our destination was the city of Oran, where our stay was only about a month. We were then off eastward to Algiers, this time overland in 2½-ton Army trucks. I was asked if I could drive, and with my affirmative answer I was put in the lead of the convoy with the commanding officer going to sleep beside me as my passenger. We took off on a thirteen-hour non-stop black out drive, once again over the Atlas Mountains. The twisting gravel-covered mountain roads were especially treacherous with the headlights blacked out. The real and unknown danger was from the military truck convoys barreling down the narrow straightaway roads between towns at night with no headlights on. One lead convoy truck came so close as to shear off my side view mirror and the metal edging on my lead truck, but we managed to reach our destination in one piece.

Our quarters for the next few weeks was a small villa high in the hills behind the city of Algiers. Our officers took over the rooms in the villa while the enlisted men slept in two-man "pup tents" in the adjacent field. I was often given kitchen details, like peeling potatoes and cleaning latrines, which was a result of showing my displeasure with the sergeant in charge. Fortunately it didn't last very long.

On my first break, I took a walk down the hill to the city of Algiers, which was quite cosmopolitan. Within the hour, I discovered a French art gallery off the main boulevard. Upon entering and striking up a conversation with the proprietor in my meager French at the time, he discovered I was an artist and asked if there were other artists like me in our group. I answered in the affirmative, stating that there was a large group billeted on the top of the hill behind Algiers. His immediate response was to plan an exhibit of GI art in his gallery. It would be the first time since the beginning of the war to exhibit American military art, and of course it would need publicity. At that point he asked if I would go down the street a few blocks, to the offices of *Stars & Stripes* to announce the opening of the exhibition. I complied with the request and strolled into their newly opened offices, which had previously housed a bank. Upon learning that I was an artist, the sergeant at the front desk asked if I had any examples of my art with me. Fortunately I was carrying a small sketchbook in my pocket containing a few renderings. He asked if he could borrow it for a minute or two and disappeared into a rear office. In a few minutes, I was beckoned to enter the office of the officer in charge, who had my sketchbook in hand. It was then that he uttered the earth shattering words, "Do you want a job?" My mouth sputtered out the words that changed my life: "oh, yes!"

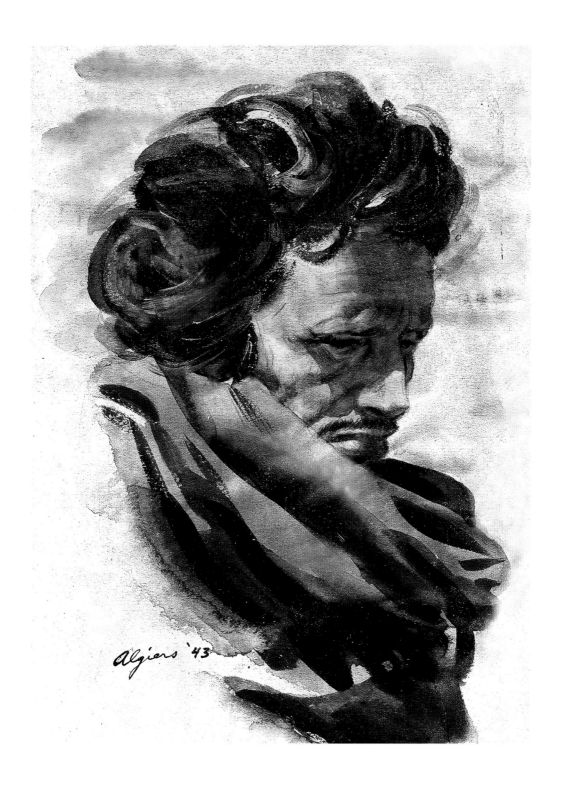

Watercolor portrait of a fierce looking Arab. I think he was a Berber.
Torn from my sketch book. Algiers, 1943.

North Africa

On the Staff of *Stars & Stripes*

No less than a week later, I was on the staff of *Stars & Stripes* which, needless to say, would prove to be a life-changing experience. As it turned out, *Stars & Stripes* was in dire need of a full-time staff artist, so I was the first and the last of the *Stars & Stripes* artists, covering 1943–46. My duty at *Stars & Stripes* consisted of being an all purpose artist, illustrating stories from the battle fronts and maps showing the progress of mainly the European fronts, and even cartooning. It was a full load of work day after day.

Shortly after, *Stars & Stripes* realized I needed more help and put in numerous requests to find me an assistant. Months passed, but still there was no one of professional ability available. Finally, help came in the form of Stanley Meltzoff, a brilliant classic painter. However, his drawings were not well suited to the rough, cheap newsprint that we used. Ultimately, he contributed mostly by making maps and some illustrations. Bill Mauldin came on the staff when we reached Naples, Italy. His job was to do a featured cartoon of "Life on the Battle Front." He did a superb job throughout the war despite a shaky start.

All of the drawings that I did for the paper were done quickly and off the top of my head without the help of models or the use of scrap clippings. In this business speed was essential. However, we did take on one more artist, who had been illustrating for *Look* magazine: Gregor Duncan, admired by all, but unfortunately killed on his first assignment at Anzio, Italy. A great loss to all of the staff, and his newly wed bride.

Algiers Casbah

Stanley Meltzoff had been a Guggenheim fellow studying in Europe before the war and spoke both French and Italian quite well. Early in 1943, he approached me to partake in a sketching tour of the Algiers Casbah, the closed and walled in original native quarter of Algiers. It was off limits to American soldiers, and the consequence was jail time if any were caught within the walls. This would be the first time, when Stanley and I sneaked into the Casbah during daylight hours in search of models to pose in the nude. We ventured into the "Street of Ill Repute" (my made up name for the street), where the unoccupied girls could be seen seated on their stoops with their bare legs sticking out—a form of advertising I presume. Their little rooms along the street were seemingly cut into the wall. After looking around, I made the terrible decision to stick my head into one of the doorways and take some photos. It was then that all hell broke loose! The girls streamed screaming from their doorways and proceeded to chase me and Stanley down the street, throwing their pillows and bits of furniture aimed at our heads. I will never forget the sunlight glinting off one of the girl's ferocious looking steel teeth as she was shouting at me. Any man would be crazy to get in bed with one of them, but with Stanley in the lead we managed to outrun the howling prostitutes. We both felt lucky to be alive from the onslaught. Some time later, Stanley managed to fill a sketchbook of charming renditions of Arab girls lolling about in a house of prostitution. The full color sketches were really excellent!

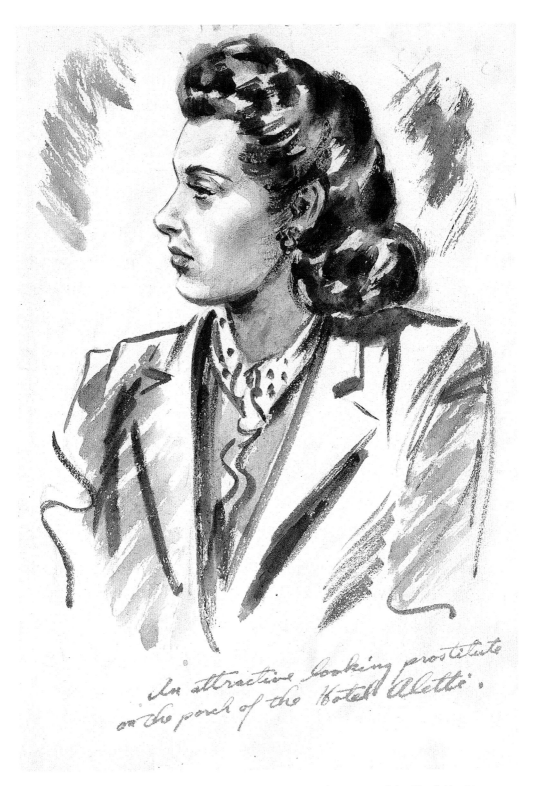

An attractive looking prostitute on the porch of the Hotel Aletti.

An on-the-spot sketch of an attractive looking prostitute on the terrace of the Hotel Aletti in Algiers. She was flattered to hold a pose for the young soldier artist, while we shared a table with drinks. March 1943.

North Africa

Algiers was my first taste of a foreign culture and deeply fascinated me. As an artist, I couldn't have imagined a beggar as ragged as the ones I saw there with their clothes stitched of one hundred or more unrelated small patches of cloth, none of them with an area greater than two square inches. Nor could I have created such an image of the constant beating of the over laden, spindly-legged donkeys with a stick. I always felt sorry for those poor animals. Though the native Casbahs were always off-limits to GIs, I would periodically sneak into their twisted spice-scented narrow streets to sketch. I carried a small, collapsible artist's stool to set up in the middle of the narrow streets. Always engrossed in my work, I once turned around to find a gaggle of young veiled Arab girls watching my progress and was impressed with the beauty of the faces that were only partially hidden behind the quite transparent veils. I memorized a few polite greetings and expressions in Arabic, which I used now and again.

AN ALGIERS NIGHT CLUB

At the French officer's club, there was both a good fencing instructor and a boxing instructor. The boxing instructor had a wonderful beat-up face from a lifetime in the ring. His face reminded me of the wonderfully sculptured head of Rodin's "God of War." I couldn't resist photographing that face. In the same military gym there was also a young Arab who more or less cleaned up. He also boxed, and I was almost certain that he was the middleweight champion of Algiers. We got friendly enough that he invited me to go nightclubbing in the forbidden Casbah. Since he was a local celebrity I felt confident enough to go with him, in spite of the tales of American soldiers found with their throats cut for straying into the native quarters.

That night, he led me down a side street in the Casbah and downstairs to a lower level large room, which at first glance seemed to be filled with white laundry bags. But it proved to be white robed Arabs seated cross-legged on the floor smoking their hookah water pipes. I suddenly realized I was the guest of honor, as I was now seated cross-legged with my friend in the center front row of the stage. Immediately in front of my knees was a raised stage about three feet high where native musicians were playing. Three young Arab girls came on stage to dance and sway to the music. The scene made for a fantastic spontaneous sketch. Then one girl departed and came back dressed only in a g-string and pasties. She proceeded to perform directly in front of me, got down on her knees, and gyrated and gyrated. My boxer friend told me in a whisper, that I was supposed to grab her g-string and stuff francs within. I complied with his suggestion, which was followed by applause from the seated guests. The young lady then got up and proceeded to pass among the Arab audience, where they all repeated the same maneuver, ending with her g-string bulging with French francs.

About three months later I went back to the same nightclub, alone this time, and found the same young girl. This time, however, she was obviously pregnant. I couldn't resist asking her age. Her response was that she was just thirteen years old.

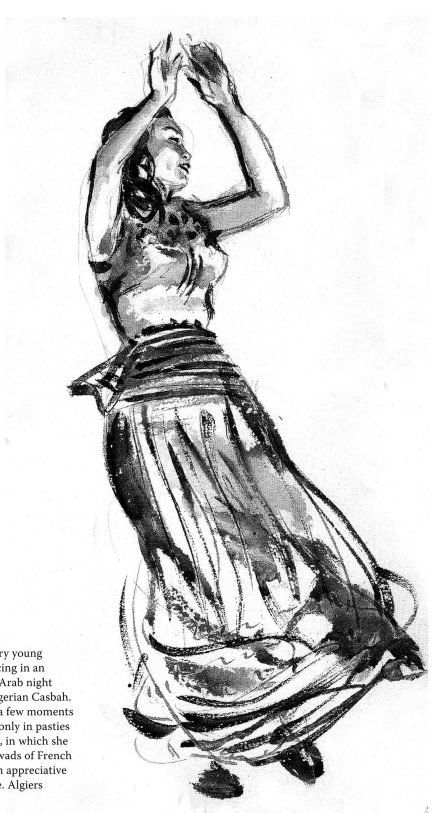

Sketch of a very young
Arab girl dancing in an
underground Arab night
club in the Algerian Casbah.
She returned a few moments
later, dressed only in pasties
and a g-string, in which she
accumulated wads of French
francs from an appreciative
Arab audience. Algiers
Casbah, 1943.

15

A French Officer's Liaison

My French cavalry captain friend that I had met in the French officer's club one day confided in me the story of how he arrived in Algiers. The peccadilloes of the French man are simply fascinating. He told me he had been stationed with his cavalry regiment in Oran, a good days drive west of Algiers. He had been having an affair with the wife of the commanding general, and one memorable night he was in bed making love to her in his darkened bedroom. Meanwhile, the husband had learned of the liaison and burst into the room with a loaded gun in his hand and fired. Both the woman and my friend were completely naked, with the lady on top of the recumbent officer. My friend said that the bullet struck the lady directly in the back. He gave her a huge push and dove out of the adjacent first floor window still naked. His feet hit the ground running. He ran straight to his superior officer and blurted out the tale. The superior officer hurriedly said that his own jeep was parked just outside the door and that here were some clothes to cover himself. He told my friend to take his jeep, take off, and don't come back! I believe the wife had been killed and the whole affair had been hushed over. Many years later while on a visit to France, I was having dinner with a group of French officers. I asked the group of them if they had heard of the affair, but nobody had any knowledge of it. Probably hushed up!

A Night in an Algerian Jail

Later, I embarked on one of my more clandestine trips to the Casbah, this time with a writer from *Stars & Stripes*. Darkness fell and the MPs caught us coming out of one of the gates. They paid no attention to the correspondent patches on our shirts and tossed us into a waiting truck. On the way to the local jail, the MPs would routinely pick up GIs sitting on the curb in various states of intoxication. It appalled me to see the MPs beat up the luckless GIs with either their fists or their clubs so they would be inert before they were tossed in the back of our jail bound truck. We were then placed behind bars. The local Algerian jail was quite primitive, with dirt floors and crude bars. I decided to fight back with my sketchbook, so I started to sketch the jailers. I made them so nervous that I remember the sergeant in charge blurting out, "Get that guy out of here!" I was released, but they kept my friend all night. Unfortunately, I don't know where the drawings are.

This is a scene of the crew from the B-24 bomber "Lucky Lady" bailing out of the rear hatch; lost and out of fuel, and with no other options but to parachute out. Miraculously all landed safely in the middle of the Libyan desert. A year later, trails of divested equipment were found as the crewmen fanned out to search for water, but no human remains.

North Africa

Josephine Baker

One of my first assignments on *Stars & Stripes* was to interview the famous American chanteuse and Folies Bergère star dancer Josephine Baker at her hotel room in downtown Algiers. In this case, I was filling in as a photographer, along with a writer from *Stars & Stripes*. I remember the event vividly because of the humor involved. We knocked on her hotel room door early in the morning and an amusing scene greeted us. The door was opened by a very short dark Arab sheik, smiling ear to ear, dressed in a long white floor length robe, skullcap, and slippers with turned up toes—an exact replica of a cartoon strip character in the Sunday newspapers called "The Little King" drawn by the popular cartoonist Otto Soglow. Directly behind the "Little King" and approaching us was Josephine Baker with a huge warm smile on her face. To complete the scene, I could just make out the bed, which had the mattress half on the bed and half on the floor. To complete the masculine fantasy was this huge oversized round metal chandelier hanging askew at a forty-five-degree angle over the bed. It was an old boyhood joke come true of the male partner swinging from an overhead chandelier and landing with bombsight accuracy on the prostrate waiting female. The two of them looked so happy after their very athletic night. After the proper introductions, we all went out on the balcony to get better light for photography.

In chatting, Josephine learned I was primarily an artist. She proceeded to inform me that she posed as a model at the famed Beaux Arts School in Paris, and of course in the nude. There upon she wrote her phone number and address in southern France on a piece of paper for me to look her up after the retreat of the Germans, adding also that she would of course pose in the nude. After a pause, she said as a matter of fact, that her figure was not as good as it once was but it was still pretty good! Unfortunately over the ensuing years, I lost her note and phone number. Pity! The sketch could have been memorable!

Drawing the Daily War

My daily work for the next nine months at *Stars & Stripes* settled down in the form of a stream of illustrating stories coming from the front, or featured stories by the writers on our staff, punctuated with cartoons and maps delineating the progress of the Allied armies against the Germans. I had taken a rented room as sleeping quarters from a French family whose fairly large apartment was quite close to the native Casbah. At night, walking back alone to my new quarters, I found it advisable to carry a cocked pistol in my hand and hoped that the moonlight would glint off my weapon to ward off any lurking Arabs who sometimes hid in the recessed doorways lining the extremely narrow and dark streets, skirting the Casbah walls. All the streetlights had been extinguished for possible air raids, but my luck held up from any confrontations. A friend of mine was not so lucky one evening and he was jumped and stripped of his clothes and belongings, but left alive. At the same time each evening, I was getting my first French lessons from the daughter of the French family. After three months, I became fairly conversant. I also attempted Arabic, which was limited to everyday phrases and salutations used in the street. Since Algerian Arabs all spoke rudimentary French, I dropped the Arabic.

RIDING ON THE SAND DUNES OF ALGERIA

At the request of help from the same French cavalry captain, whom I had met at the French officer's club, I began to help exercising the neglected cavalry horses stationed on the outskirts of Algiers: this was because the officers were chasing after the French girls in town and neglecting the horses. So, for the next three months the captain and I rode about two times a week on the outskirts of Algiers. Several horses would be waiting along with a couple of military Arab grooms, standing at attention, holding the horses between the Algerian shoreline and the adjacent sand dunes. The captain and I would start out racing into the salty surf along the shoreline, then turn into the encroaching and desolate sand dunes. Riding in the soft sand dunes gave the horses a good workout: it was a bit like reliving Lawrence of Arabia! My assigned horse was impressive, a cross between an English hunter and an Arabian Berber. Initially, he had to be held down by two grooms, his eyes wild and bloodshot. He was named *Mahboul*, which in Arabic means "crazy horse," which he sure was until I was able to calm him down. Later, we became best of friends and even swam across a river together. On the other side of that same river was a small picturesque French café with a blue and white striped awning. An aproned French waiter appeared to take our order of aperitifs, which was served from a silver tray, while we still remained in the saddle. Complete decadence!

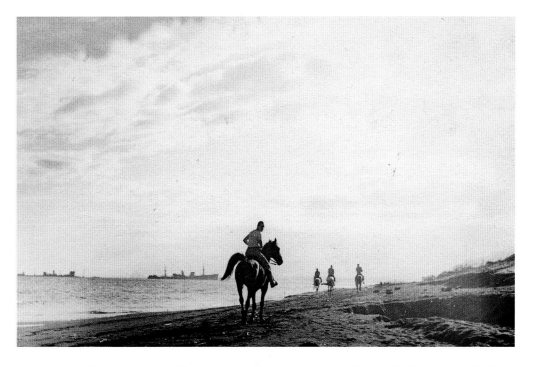

The author in the foreground, riding along the Algerian shoreline, along with Capt. Robert Neville of *Stars & Stripes*, and the hosting French cavalry officer. Note the US Navy vessels in the distance.

North Africa

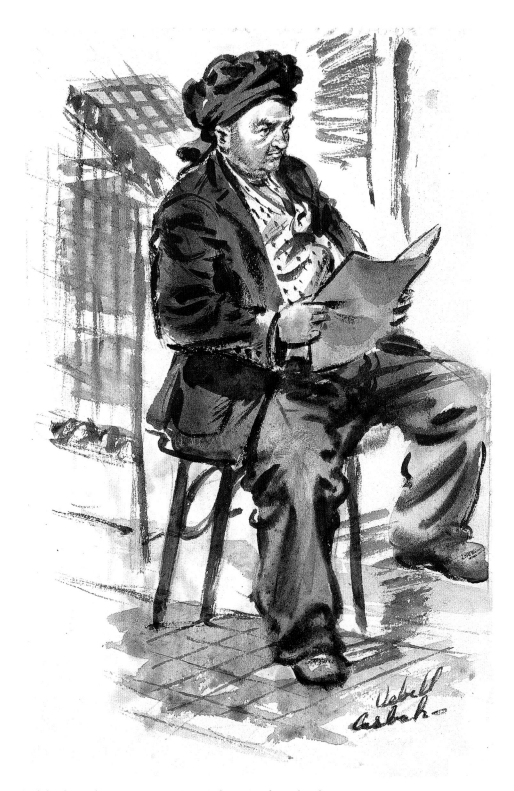

Arab bird merchant cooperating in quietly posing for a sketch
in the walled off native quarter of the Casbah of Algiers.

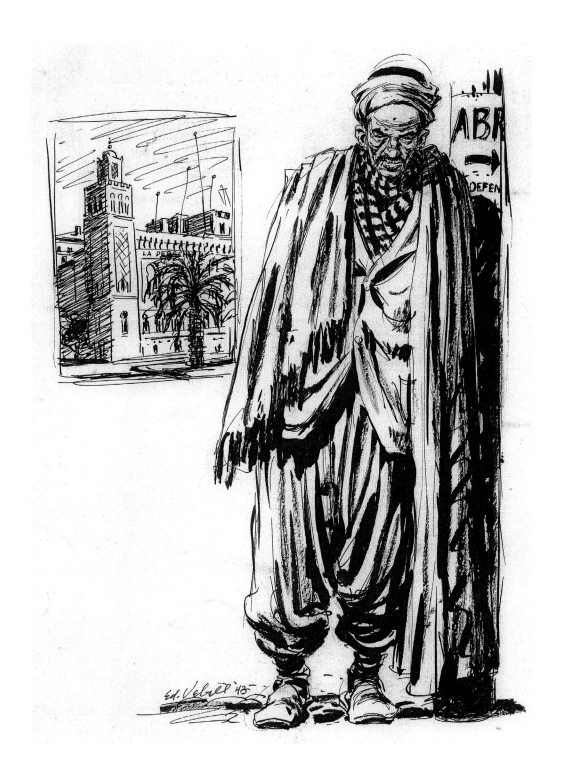

Street study of a glum looking Arab. Probably thinking about the future of
a French free North Africa. Sketch book drawing. Algiers, 1943.

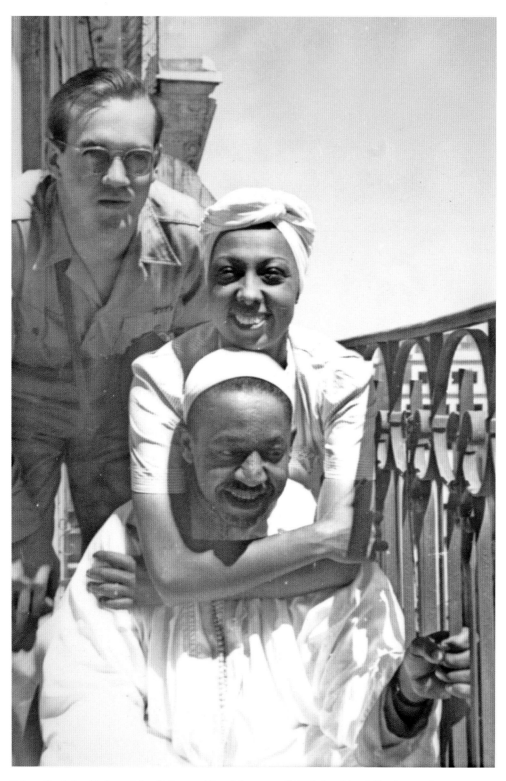

Ed on the left with Josephine Baker, and her "sleep over" Arab boyfriend. Both were in a happy mood after spending the night in their rented Algerian hotel room.

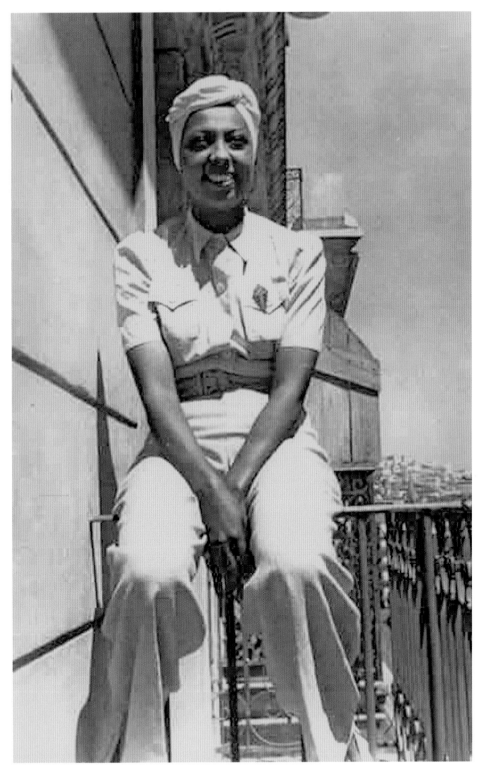

Josephine Baker posing on the balcony of her Algerian hotel room. She exuded a warm outgoing personality and was someone to treasure as a friend. It was a big loss when I lost her address and phone number in the south of France.

North Africa

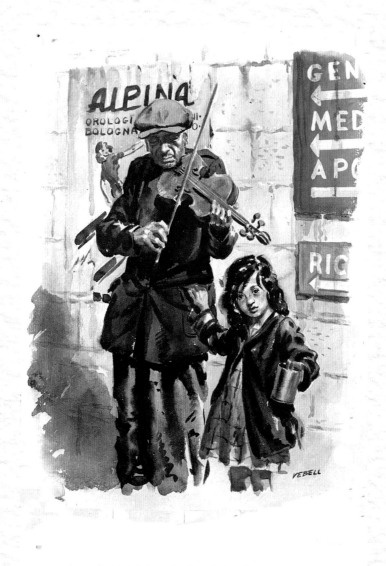

Demobilized Italian soldier literally playing the violin for his supper, and his daughter begging for a few lira. Italy was broke and jobs were impossible to find, hence begging was rampant. The lucky ones found work with the American military.

2

ITALY

The Invasions of Sicily and Italy

Next came the Allied invasions of Sicily and Italy. *Stars & Stripes* moved its operations to Naples where our art staff increased by three, with the addition of Bill Mauldin, who was to do his wonderful, thoughtful featured cartoons until the end of the war. The two heads of *Stars & Stripes* were Col. Egbert White, who had been on the staff of *Stars & Stripes* in World War I, and Capt. Robert Neville. They were figureheads and kept a low profile, since the newspaper was run by and for the enlisted men. When I came on, there wasn't an artist or cartoonist, so I had to do it all, including map making. I was under a lot of pressure and under deadlines to produce artwork daily, and I needed help.

That's when I first heard Bill Mauldin's name coming from the 45th Division newspaper. He was transferred to *Stars & Stripes* when we got to Naples. I was unfamiliar with his work, but I vividly remember his first cartoons for the paper, which were not good at all, by my standards. He had opted to do his first drawings in an anemic pen line, which reproduced poorly on the cheap newsprint we had available. So I called him over to my drawing table and told him since it was wartime he had to get more "guts" in his drawing. I then proceeded to give him a drawing lesson in brush handling of "thick and thin" lines, and how to delineate the cascading folds and creases in a GIs pants after he has been in the front lines for a month. Bill watched me for half an hour, turned around without saying a word, and left. He changed his technique overnight and became the Bill Mauldin as we know him. He never changed that technique for the rest of his life. I never thought about it at the time, but it would have been nice to have heard a "thanks."

About a month later, one of our staff members made the comment that my work looked like Mauldin's. He was already getting a name, so in self-defense, I had to change my technique, much to my chagrin. We however remained bound together for the next two years. There was always an air of resentment on his part that he "owed" me for the drawing lesson. It was subtle and I couldn't have cared less.

With Bill Mauldin in Naples

While in Naples, Bill and I started dating two attractive cousins. We went to the beach just north of Naples called Marechiara. It was all very platonic, as their mothers chaperoned us the entire time. I took photographs, some of which I still have. Bill made me burn most of the photos I had of him with the girls. He was afraid his wife back home might see them and cause trouble. He was basically a very "good little boy," except for one week in Grenoble, when he got the contract to write *Up Front*. While we were in Naples, he started to compile his cartoons in pamphlet form, and place them next to the daily newspapers, which were being picked up by a mail clerk from the outlying companies and regiments. A small cash fee was paid for the pamphlet of cartoons, which went into Bill's pocket. I don't remember what price was put on the pamphlets, but after about a month, Bill complained to me he was making too much money from the private cash sale of the booklets and he didn't know what to do. You are not supposed to make extra money while you are in the military. Bill Estoff, our circulation sergeant overheard our conversation, came over to us, and said, "Bill don't you worry your little head about this. I'll take the matter over," and he pocketed the money from then on for himself. I found out years later that he was able to reopen his "bookie" operation in upstate New York from the proceeds of Bill's cartoons.

About this time Bill decided to try to have his cartoons published in a larger booklet form, which he titled as *Mud, Mules and Mountains*, wherein he described and drew the awful fighting conditions in the mountains around Monte Cassino, Italy. Bill asked me to interpret in my rudimentary Italian with the Italian printer who worked in the bowels of the building where the *Stars & Stripes* was printed. The big decision was: should the booklets be stapled or stitched? This was the start of his publishing career.

Bill had been able to finagle his own private jeep and was free to roam the action at the front while I had to wait to be assigned to go to the front and sketch what I observed. As a result I tried to transfer to *Yank* magazine where the artists were free to roam the fronts from the Pacific to Burma and Europe, but *Stars & Stripes* refused to let me go; but I did a lot of my best work for *Yank*, so they considered me as part of their staff as well. Andy Rooney and Ralph Martin had the same status, a sort of dual citizenship, between *Stars & Stripes* and *Yank* magazine.

Bill Mauldin's Cartoons

Bill told me he had a hole cut out in the roof of his jeep with a flap, so in bad weather he could just pop his head out of the top of his jeep and observe and sketch, and still keep reasonably warm. We talked about joining forces when we got back to the States: to make a sketching tour of the western part of the US from a rented mobile home. but it never happened. Bill once gave me a useful frontline observation: "Ed, did you ever notice the difference of a dead soldier's feet, which relaxes to almost parallel to the ground, but if he is still alive, his feet are more at right angles to the ground." I thought that this was useful information for a war artist. Occasionally, I would hold a pose as

Unsigned original drawing by Bill Mauldin that inadvertently got mixed in with my own artwork brought back from Europe. His use of a "thick and thin" brush line he learned from me. I donated a free drawing lesson during his first week on *Stars & Stripes* in Naples; it was just basic brush handling that was common knowledge to all illustrators. He stuck by it for the rest of his professional life. He never thanked me, and I never expected a thanks. It was just "do a good job" on the newspaper!

either Willy or Joe, whenever Bill needed a pose. It always amazed me that he could sit caddy corner from me in our two-man studio, and in about three hours he could come up with at least four great ideas for his observant cartoons. I have to tip my hat to him for this skill. I'm sure I tried his patience at times for bringing in young ladies to our studio as possible models to pose for me. I can still hear his voice admonishing me to "get those girls out of here, I can't think!" Years later I finally got around to reading his book *The Brass Ring,* the story of his life, and I was very impressed with his writing skills. I wish he were still alive so I could tell him how much I enjoyed his book. He found humor in the most mundane situations. I envy him that ability.

Before Bill joined the *Stars & Stripes* staff, I was recreating and illustrating daily news dispatches from the battlefronts. The editors would sometimes ask me to find something funny in the battle reports. Now that is a very tough call. I must have handled the request somehow. That never seemed a problem for Bill Mauldin.

On March 5, 1944, Mt. Vesuvius, looming next to the city of Naples, erupted with a two-week display of nature's fireworks, seemingly in competition with the cascade of mobile artillery fire coming down from the German paratroopers, who had captured and held the heights of the Monte Cassino Abbey for the next several months.

Italy

Fencing in Naples

In between creating daily illustrations and maps depicting the progress of the Allied armies northward up the boot of Italy, I found time to take fencing lessons from an Italian Army professional fencing master by the name of Domenico Conte, whose brother was an admiral in the Italian Navy. *Signore* Conte was a cavalry officer and wore his cavalry boots and breeches while giving fencing lessons to his one and only pupil (myself) in two languages, French and Italian. The lessons took place on the empty third floor of a palatial building in the very old city of Naples, with cherubs painted on the ceiling from a former life. The first two floors had been taken over by residents of Naples, who at mid-day were cooking pasta by the bucketful. The smell, which in turn, permeated to our third floor windows in the hot July Naples sun, caused us to shut the windows, and somehow bear the heat in our sweat soaked canvas, fencing jackets. I was down to 135 pounds.

A few days later while visiting the home of *Signore* Conte, the air raid siren sounded and everyone dashed for the closest shelter. The German Luftwaffe made periodic bombing drops on Italian cities in retaliation for surrendering to the Allies in September 1943. The women and children in the shelter were weeping in fear, but fortunately nothing landed close by and the "all clear" sounded with everything back to normal. Except for the raging typhus epidemic spreading through Naples, resulting in a continuous chain of black plumed horsedrawn hearses on their way to the out-lying cemeteries.

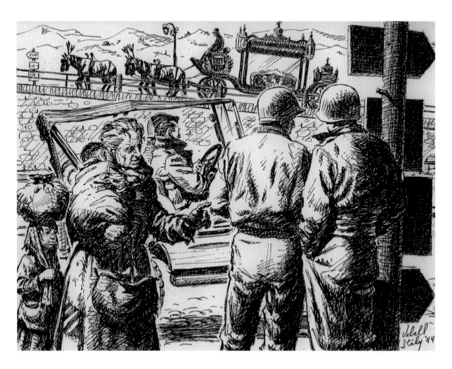

The winter of 1943–44 brought on a severe typhus epidemic to the poverty stricken city of Naples. There was an unending stream of black horse drawn hearses carting the bodies out of the city. The liberal use of DDT dusting powder on the civilians of Naples, eventually brought the disease under control.

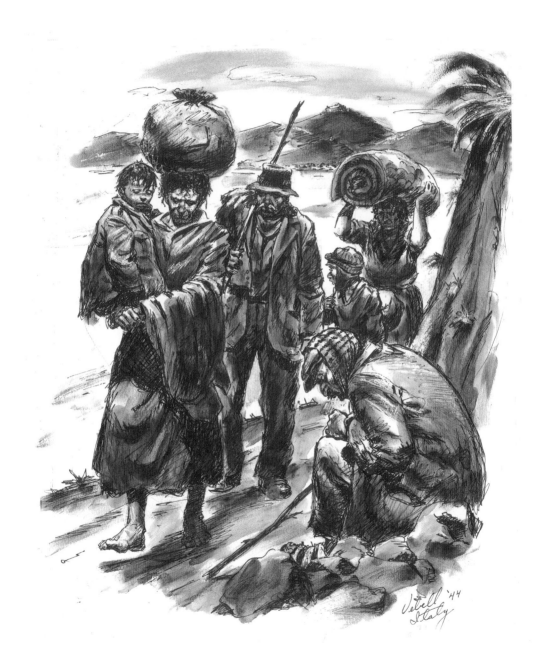

Italian refugees streaming out of the war torn villages of southern Italy, and also escaping the severe typhus epidemic then raging in Naples. To add to the misery, Mt. Vesuvius was putting on a daily and nightly display of dramatic eruptions, causing more villagers to flee. Naples, Italy.

Italy

NAPLES PROSTITUTE AS ARTIST'S MODEL

I nearly forgot one of the funniest stories while we were still in Naples. Stanley Meltzoff was our other staff artist in Italy, who stayed in Italy for the duration of the war on the Mediterranean edition of *Stars & Stripes*. He and I had gone on a couple of exploratory expeditions looking for models to pose for us, such as the Algerian Casbah. This time he successfully talked a large-framed Napolitano prostitute to pose in the nude at her place of business. She had dyed her black hair blond to better serve the German officers. Since the Germans had recently retreated northward, she was letting her natural black hair grow back, so it was weird to see her half blond, and half black hairdo.

Stanley invited me and Bill to participate in the sketching séance, but the word got around to the editorial staff, as to our art project. About seven of the writers immediately proclaimed themselves as artists and wanted to join our group. I remember they each took one sheet of copy paper and a pencil and off we went. The destination was on the third floor of an upscale building with a tight spiral staircase, with Stanley leading the way. Stanley knocked on the door, but this time a completely different working girl answered the door. She looked aghast at all the GIs spiraling down the tight staircase and proclaimed proudly, "we only cater to officers." Whereupon Stanley explained in Italian that we were all artists and that he had made a previous arrangement with her partner to pose for us. She reluctantly agreed to let us in, but with the provision that we hide somewhere, as her partner was busy at the time with an officer client in another room. So we filed in, but the only place we could see to hide from view was under a large sofa in the living room with dangling fringe. I don't know how we managed to squeeze under the sofa like sardines in a can while peering out from the protective fringe.

Finally the officer came out with his serveuse following. All we could see were his boots crossing our vision; I'm sure he would have died if he only knew seven pairs of eyes were following his every step. As soon as he was gone, we climbed out of our hiding place, much to the astonishment of our potential model. Stanley refreshed her memory as to their arrangement, so we filed into her large well-appointed bedroom where she stretched out on the bed in the nude for a pose. The writer's attempts to draw the female figure were pitiful! They all consisted of two adjacent balloons with a center dot for nipples. Just then the outer door slammed. The model jumped off the bed in fright, exclaiming that her pimp had arrived and he would be very upset to see her with all these enlisted men! We paid her and filed out, while passing her pimp near the doorway.

Mauldin made a cartoon of the entire event. It was a scene depicting a king sized buxom prostitute holding an open door, with all of us filing out under her arm like the seven dwarfs (he made portraits of all of us), with the surprised pimp leaping for joy with a dollar filled balloon over his head, intimating the amount of money the prostitute must have made by servicing seven men at once. I'd like to know what happened to the cartoon. It would be priceless today!

Finally, Bill Mauldin's cartoons came to the attention of "spit and polish" Gen. George Patton, who was very displeased with Mauldin's unkempt delineation of the American GI. I felt some degree of responsibility for the situation, as I had previously shown Bill how to draw the clothing on a bedraggled GI, especially after he had spent days or weeks in a foxhole. After some futile attempts to placate Patton, it took Gen. Eisenhower to intercede on Mauldin's behalf to ease up on him. A welcome reprieve!

Monte Cassino Campaign

During the Monte Cassino campaign in 1944, the Allied armies were bogged down in the foothills of the mountain, with the 4th Regiment of German paratroopers in command of the heights. The Germans set up their positions just below the ten-foot thick walls of the Benedictine abbey. Meanwhile, refugees had poured into the fourteenth century monastery seeking safety. Some 230 civilians became casualties. Gen. Mark Clark commanded the 5th Army in the boot of Italy and, with faulty intelligence, he sent out the order to air bomb the abbey. Wave after wave of high altitude bombing reduced the abbey to rubble. This made ideal cover for the German mobile artillery and sharpshooters.

The Germans promptly moved back in to take advantage of the holes in the walls. It was a cat and mouse game from then on. The German mobile artillery could fire down from one position, and before the Allied spotters at the bottom of the mountain could pinpoint the source of the flash, the German artillery had moved to a newly opened firing position. It was a frustrating game that became a stalemate for the next four months.

The conditions were horrific with the incessant cold rain and mud making it impossible to bring up supply trucks and tanks. Mules became the only supply lifeline. Four futile Allied assaults involving the Americans, British, Canadians, Free French, Algerians, Moroccans, New Zealanders, Australians, Poles, Indians, and even Brazilians came to no avail. On May 18, 1944, a patrol of the Polish 12th Padolian Polish cavalry made it to the newly evacuated heights and raised a Polish flag over the abbey ruins.

Baron Rudolph Karl von Ripper

When *Stars & Stripes* had moved its office to Naples, Italy, I was able to get to the front to do some of my best work of recording the war. Bill Mauldin had just been transferred from the 45th Division to the *Stars & Stripes*. His cartooning talent had been nationally recognized, and I needed all the help I could get on the newspaper. At the same time there were groups of artists commissioned by the leading magazine publishers as well as the War Department to record and paint the war.

One such group of about seven civilian artists arrived in Naples in early 1944.

They were dressed in officer's olive drab but with civilian style war correspondent's patches on their shoulders, indicating they were civilians and not army. They came up to the *Stars & Stripes* office requesting to meet the art department, which consisted of myself, Bill Mauldin, and Stan Meltzoff.

One of these artists stood out, mostly from his military bearing. He looked to be in his late thirties, with a closely cropped German style hair cut, erect military bearing, and a heavy German accent. We immediately struck up a conversation and after I had mentioned that my parents had originated from Lithuania, he immediately warmed up to me and started to tell me of his background—first about his Lithuanian college chums in East Prussia where he had been schooled. He was born in Austria in 1905, with both his father and grandfather being generals in the Austro-Hungarian Imperial Army in the last two European wars. His name was Baron Rudolph Karl von Ripper, and he was brought up and trained to become an Austrian general like his father and grandfather before him. At the same time he had also pursued a parallel career as a trained artist. He casually mentioned that this was his fifth war. I can only remember three. He ticked off the Spanish Civil War of the mid 1930s, where he fought for the Republican Loyalist side, followed by a war in Yugoslavia of which I had no knowledge. Then came a stint with Mussolini chasing the natives in Ethiopia. I found out later that he had been incarcerated for months in the newly formed concentration camp at Orienburg, Germany in 1933–34; this camp became an earlier version of the future infamous German concentration camps. Writers, intellectuals, politicians, and Catholics became the first occupants. He then served in the French Foreign Legion, where he had fled to avoid further persecution from the Nazis. I believe Hitler had ordered his mother and father to be killed and their considerable wealth confiscated! He fled to the US and enlisted in the US Army just before America entered the war, and was stationed in Texas. His overriding desire was to return to Europe by any means to kill Nazis for revenge. He managed to join forces with a European bound group of seven artists commissioned to "paint the war." This is when the same group of artists showed up at the Naples offices of *Stars & Stripes* to meet Bill Mauldin and myself.

That night Mauldin invited all seven artists, plus myself to his small apartment for some wine and snacks. We all arrived about 1800. I remember Bill pulling down the window shade to hide any errant light giving a tempting target to any stray Luftwaffe night bomber. We were all having a good time drinking and swapping stories. At the same time, there was a congressman back in the States who had heard of the seven artists. His decree was that these young capable men should not have brushes in their hands but guns! So he rescinded their status from being civilians, to the US Army as buck privates. At about 2100 that evening, I answered a knock on the door, which opened to a military policeman standing with a paper in hand. He read off all the artists' names and asked if all were present. After an affirmative answer, he announced that they were all now privates in the US Army, and all now had to report to their closest Army Replacement Depot by 0600 that

Rudolph Karl von Ripper's story is one of the most fascinating of WWII! He fought in five wars. He drew a derogatory, published sketch of Hitler, and spent two years in a Nazi concentration camp for it. He escaped to the US then returned to Europe as a private in the US 34th Infantry Division. He personally captured scores of German soldiers at Monte Cassino, Italy. Truly, a one-man army!

Italy

morning. The wine then flowed like water and everyone got very drunk, but by 0600, they were all gone.

A few weeks later *Stars & Stripes* began hearing strange stories coming from the front about a lone soldier making forays into the German lines and coming back with groups of German prisoners. This sounded like a good story for the paper and Marty Harris, our photographer, was elected to "get the story." Marty kept his cameras in my studio, as I had a lock on my door. He disappeared for three days, and on the fourth day he reappeared to put his cameras back in my studio room. I asked him, "what happened, Marty?" His retort was, "Ed, it's our old friend von Ripper!" He had been inducted into the 34th Infantry Division as a buck private, which started his new life as a one-man marauding army! He proceeded to tell me that he accompanied von Ripper across the Rapido River, and then into the German lines. German rifle fire started to land all around them. Marty said that he had hit the dirt and frantically tried to dig a foxhole to get some cover. Then he looked up and said, "the S.O.B. was standing bolt upright with a sketch book in his hand, and was sketching the Germans, who were firing at him." But luckily nothing had hit him at this point. He then yelled out in his German general's voice, and all the firing immediately stopped. He casually walked into the German lines and disappeared. After about half an hour, all of a sudden about twenty Germans came out with their hands up and started walking towards the American lines, followed by von Ripper in the rear with his sketch book. Marty jumped out of his improvised foxhole, and asked excitedly "von, von, how did you do it?" His retort was "when a German general speaks, the German soldier obeys!" Von Ripper continued to repeat this unheard of feat for another month, capturing scores of prisoners. He had a hard time coming back to the American lines with his heavy German accent and with all these prisoners in tow. As a reward he was given a battlefield commission from private to second lieutenant and later to first lieutenant. The last time I saw him was when he came to the *Stars & Stripes* office in Naples to visit Bill Mauldin, but I saw his hand was all bandaged up. I questioned it, and he told me that finally a bullet took off one of his fingers,while he was sketching. This was true "combat art." One crowning achievement by von Ripper was a surrealistic depiction of Hitler playing an unholy organ with his victims dangling from a St. Catherine's wheel, with the Nazi hierarchy bearing witness! It was published on the cover of *Time* magazine on January 2, 1939. One can only imagine Hitler's reaction!

The parallel career of von Ripper as an artist and warrior is fascinating! He served with the 34th Division in Italy, constantly volunteering to patrol behind enemy lines. He was wounded twice and credited with killing sixty-three Germans personally! He earned two Silver Stars, and two Purple Hearts. He ended up as a captain and in charge of the OSS in southern Austria by December 1945. Ernie Pyle on meeting von Ripper, described him as the most interesting and fearless man he had ever met! The story of Baron Rudolf Karl von Ripper should some day be made into a movie! To me, his story is one of the most unusual in all of World War II!

Sketching Monte Cassino

Stars & Stripes sent me back and forth to the Monte Cassino front. The usual routine was to drive me in a *Stars & Stripes* jeep as close to the front lines as possible. I would be dropped off with only my sketchbook and drawing pen to find my own stories, with the promise that someone would return after three days to pick me up. My only asset and protection was the correspondent's patch on my shoulder. In all the ensuing years after the war, I am still haunted by the looks in the eyes of the men who had to stay at the front and probably die while I had the privilege to leave at my own discretion.

The northward progress of the Allied armies was being blocked by the German superior "high ground" vantage position of looking down on the troops below. The frustrated French called in their colonial troops fresh from the Algerian desert. The French called them *Goumiers*, or *"Goums"* for short. They were dressed in full length *Jellabas*, or burnooses with hoods, and open toed sandals on their feet. They were all mounted on horseback, some trailing a lamb for dinner on the end of a rope. They were a colorful lot and respected for their abilities with a knife. They were to be used as night fighters, to crawl up the sides of the mountain on their hands and knees searching for sleeping Germans in their foxholes, under cover of total darkness. Their mission was to feel the texture of the helmet. If the texture was rough, they would crawl on and upwards. If the texture was smooth, indicating a German, they would slit his throat and continue on in the dark, searching for sleeping victims. The Germans, finding the bodies the following morning, indignantly radioed down to the Americans below that "this is no way to fight a war!" Shortly afterwards the *"Goums"* were rewarded with shoes to ward off the snow and ice on the mountains of Monte Cassino.

On my next assignment to the front at Monte Cassino, I worked my way up to a forward command post where it was pitch dark. The few officers and sergeants spoke in hushed voices and read maps by flashlight. Earlier in the day there had been a fierce fight and there were considerable casualties lying in the field just outside of the command post. The Germans radioed to the Americans, asking if a truce could be called in order to clear the field of the dead, and the Americans consented. This brought the two sides into close proximity to each other. After a few hesitant exchanges of conversation, the inevitable process of souvenir exchanging commenced. The Americans had chocolate bars and the highly prized American cigarettes on their persons. The Germans had schnapps in their canteens, loose insignia, plus a fairly large Nazi flag, all to be swapped. The entire scene got so chummy and friendly that the Germans invited the Americans over to their side of the line to have dinner that night. After considering the proposal for a minute, the Americans accepted the offer. But it would hinge on the approval of their officers back at the command post. Of course on their return, and repeating the invitation from the Germans, the American officers exclaimed, "No Way!" In hindsight, it's a pity, because that moment could have been a turning point in the war. It could have started a much larger truce and a shorter war. I still have the drawing of the American soldier holding his souvenir Nazi flag.

My last trip to Monte Cassino was on a cold, wet, and muddy day for *Stars & Stripes*. A barrage of artillery fire from the heights of the abbey pinned me down next to a farm hut. There I heard moaning coming from an open window just above my head. Peering in< quickly photographed (and later drew) a medic extracting shrapnel from the back of a wounded soldier. Later the same day, I met and sketched Brig. Gen. Teddy Roosevelt, Jr. He was resting stretched out on an old iron posted bed in his stocking feet in a two room farmhouse. Shortly afterwards during the D-Day landings on Utah Beach, he had a fatal heart attack. The pencil sketch portrait is still in my sketchbook.

The fourth assault to capture the abbey of Monte Cassino by the Allied forces was finally successful, and the road to Anzio and Rome was open. We also mourned the loss of our newly acquired combat artist Gregore Duncan, who was killed during the assault on the beaches of Anzio.

Rome fell to Gen. Mark Clark on June 4, 1944. He planned and hoped to be the first commander to liberate the city of Rome. Not far behind was *Stars & Stripes*, requisitioning space and printing facilities at the Italian daily newspaper Il Messagero. My two-month stay in ancient but beautiful Rome consisted of the usual daily barrage of illustrating the progress of the Allied armies and featured stories by the editors. I managed to meet, and receive a fencing lesson from, the professional fencing master of Rome, Agisalaco Greco. The lesson was more suited to the ancient art of dueling than to the sport of fencing. Dueling was obviously permitted in Italy, as one could purchase a pair of sharp dueling weapons in any major city. I still have mine.

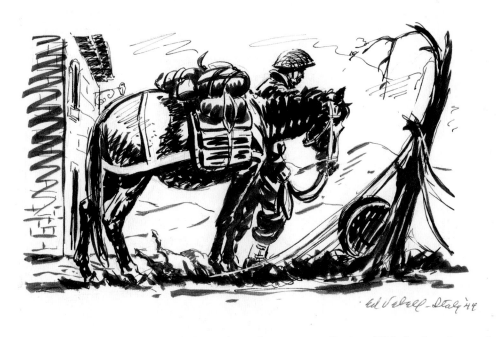

Sketch of a British Ghurka trooper laden with supplies at Monte Cassino. With the American and British troops stalemated, and pinned down at the bottom of the mountain of Monte Cassino, calls came in for assistance from the Allied colonial troops and the Poles. 1944.

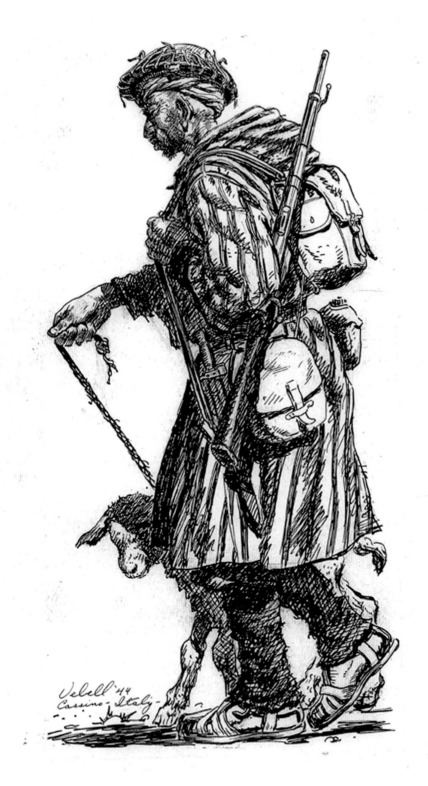

A French Algerian native trooper was called *goumier* or "*goum*" for short, brought to Monte Cassino, Italy, directly from the desert, still dressed in his open toed sandals, in spite of the snow covered mountains of Italy. The lamb was destined for the evening dinner.

Italy

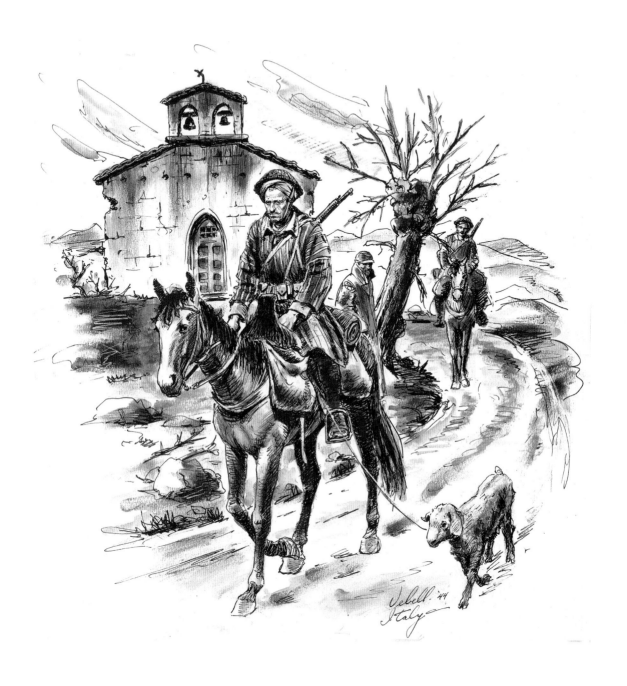

Another view of the Algerian French *goumiers* on horseback, this time wearing shoes as a reward for finding and killing sleeping Germans in their foxholes on the slopes of Monte Cassino.

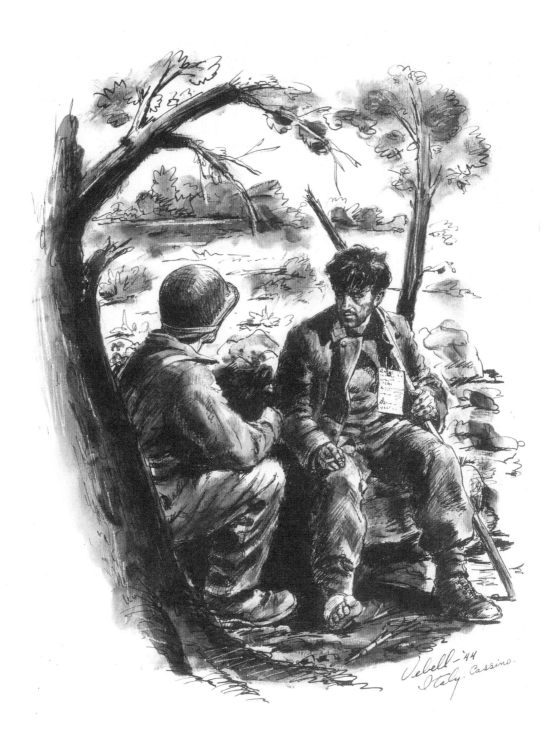

Captured German prisoner being interrogated by a GI translator. The prisoner turned out to be a Polish conscript in the German army. Monte Cassino, Italy, 1944.

Italy

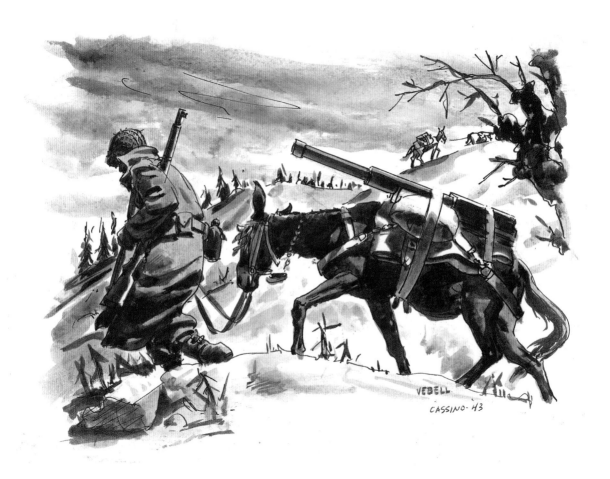

Due to the impassable conditions of snow and mud on the slopes of Monte Cassino, the always reliable mule was put back into service, transporting ordnance to the mountaintops. Monte Cassino, 1944.

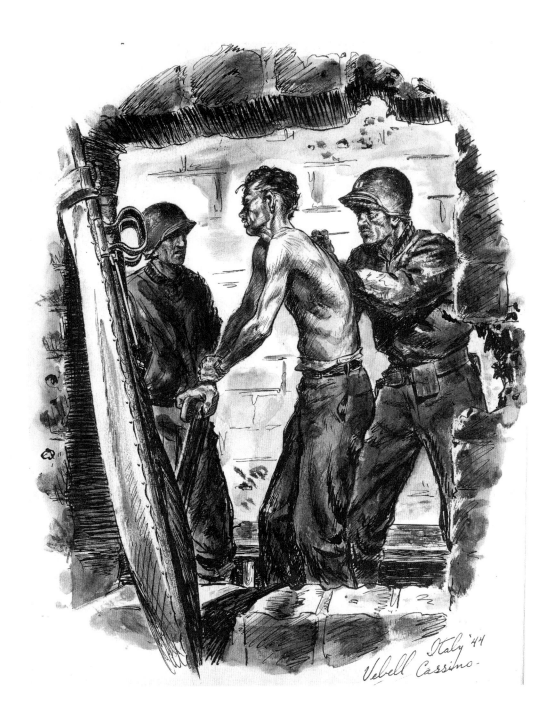

Sketch made from a quick photo taken during a shelling by German 88 guns. An officer medic was removing shell fragments from the back of a GI, with the natural ensuing moaning. Monte Cassino, Italy, 1944.

Italy

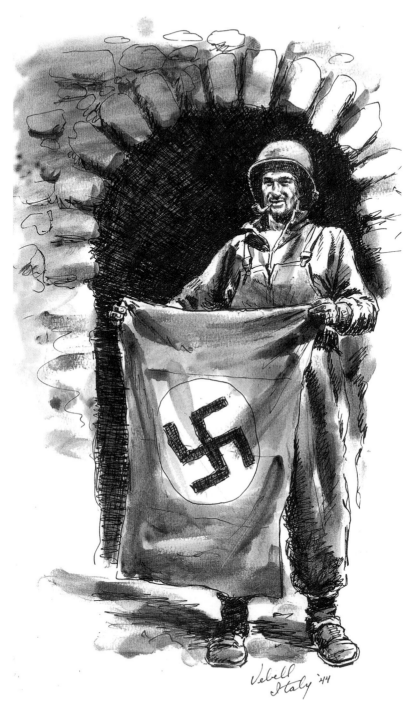

GI exhibiting a souvenir Nazi flag, traded for cigarettes and chocolate from German soldiers, during a temporary truce called to clear the dead from the battlefield. With the two sides in proximity to each other, conversation and exchanges of souvenirs invariably took place among soldiers. This resulted in an invitation for dinner by the Germans to their side of the lines, which naturally had to be refused. But it is intriguing to contemplate that the war could have started to end that day! Monte Cassino, 1944.

Snapshot of Bill Mauldin; taken for no good reason, other than we worked
together for some two and a half years. Although in reverse, sometimes I had to
strike a pose as either Willy or Joe. It was mostly for reference in the folds in an
arm or pants leg. Years later, I really began to appreciate his writing talent and the
ability of finding something funny in everything he observed. A rare skill!

Italy

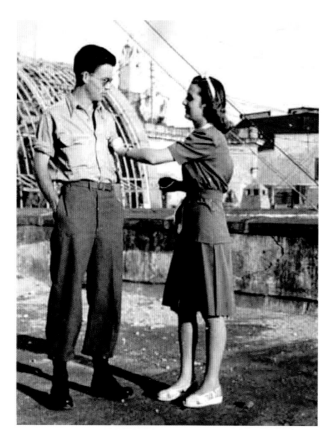

Photograph I took of Bill Mauldin and his girlfriend on the rooftop of a large commercial and residential building at the center of teeming Naples. It was named "La Galleria," was four stories high, and only retaining the supporting framed arches of the bombed out glass roof. Bill Mauldin was now at the point where he was getting international attention for his award winning "Up Front" cartoons in *Stars & Stripes*.

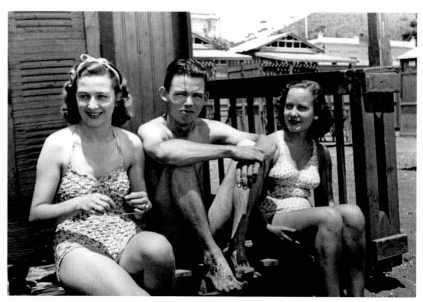

Bill Mauldin on the beach with his girlfriend and my temporary girlfriend. The two girls were cousins and they came with their mother as chaperones, so our double dating was very platonic! The beach was Marechiara, just north of Naples. Bill made me burn most of these photos, as he was afraid his wife back home might see them. 1944.

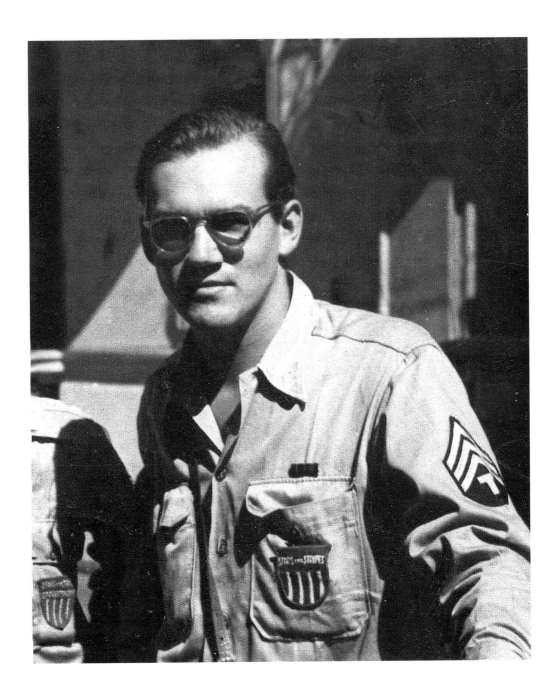

The author with a *Stars & Stripes* patch on his pocket and technical
sergeant rank on the sleeve. Naples, Italy, 1944.

Italy

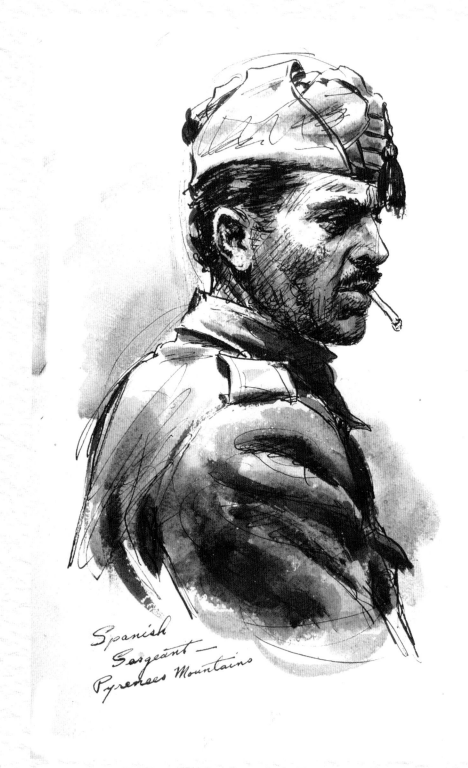

Spanish
Sergeant —
Pyrenees Mountains

Portrait sketch of a sergeant in the Spanish border guards under Franco's rule. 1944.

3

FRANCE

INVASION OF SOUTHERN FRANCE

August 15, 1944 dawned and brought forth the invasion of southern France (Operation Dragoon). *Stars & Stripes* immediately decided to send a skeleton crew to southern France to start up a new branch of the newspaper. About six or seven of us (including myself) boarded a DC-3 from sunny Rome and headed northwest to a makeshift landing strip in St. Tropez, France. Our first night was spent amongst a grove of pine trees adjacent to the landing strip, pushing together a mound of pine needles to make a comfortable bed and a good nights sleep. The next day we headed toward the city of Nice, about 400 miles to the east to open the first edition of *Stars & Stripes* in France.

My very first art assignment in Nice from the editors of *Stars & Stripes* was to seek out Henri Matisse, who was then residing in the town of Vence, just a short drive west of Nice, and to do a portrait of the renowned painter. The intimidation of his name took over and I turned down the assignment, with later ever present and ever lasting regret. I now fantasize that we might have become good friends, and I could have sold the portrait at Sotheby's for a goodly sum at a later date of my choosing.

MEETING LYSIANE HERAUD

I spent over two years, every night, at the Folies Bergère, while at the same time being on the staff of *Stars & Stripes* in Europe during World War II, as an artist/reporter.

It all started at a wintry Christmas party for the staff of *Stars & Stripes* in Marseille, France in 1944. Two of the invited guests were Edith Piaf and her consort Yves Montand, who looked to be about twenty years of age. They were a small troupe of traveling entertainers, about six in all, including four accompanying showgirls, one of which was Lysiane Heraud, an attractive seventeen-year-old. We had an instant mutual attraction that night. They all left the following day and a week passed. I then received a phone call from Lysiane asking if she could stay with me. Of course, I answered in the affirmative. I was so young and this was my first affair, which stretched into years. *Stars & Stripes* would requisition a hotel to billet its roster of professional writers, photographers,

pressmen, and a few officers who kept a low profile. Lysiane moved in with me in our newly requisitioned quarters. We set up shop as close to the lines as possible as the Germans retreated northward. Since Lysiane was living with me, I understand she was included as just another GI in our ration list for food.

Marseille, France

The seaport of Marseille had been heavily destroyed by the retreating Germans, but the French had already rebuilt the wharves and walkways with wooden planks, so the fishermen could get out with their boats. I roamed the back streets of Marseille, at the same time noting the overflowing antique and bookshops. I believe this was due to the fact that Marseille was the last stop for the Jews of Europe escaping the persuing Germans. The Jews were selling their belongings in exchange for a steamship ticket to America. I only purchased a few books from these shops, which I still have.

"No Man's Land" between France and Spain

Before that winter set in, I received an assignment to cover an uprising of Spanish Republican Loyalists against Franco's troops on the French-Spanish border. I left Marseille and headed westward to the Atlantic Ocean along with George Dorsey, a *Stars & Stripes* writer.

There seemed to be very little sign of life. The Germans had retreated north and east, leaving a quarter of France bare of military domination. The few civilians we encountered had never seen a jeep before, and swarmed over it in fascination, nor had they ever seen an American soldier. We were treated like a two-man conquering army. The same scenario was repeated all the way to the Atlantic coastline, where we found a French garrison manned by a mixture of French resistance fighters and Maquis. They had no idea who we were, but with a war correspondent patch on my shoulder, they treated us royally. First we were treated with a true French omelet heavily laced with cognac. It was proudly brought in by a white toqued chef carrying in the flaming omelet on a silver tray over his head. A vintage bottle of cognac was brought in to wash it all down.

Since my French now was quite good, I was chosen next to review their troops in the enclosed parade ground. Although I was only a sergeant at the time I had to pretend I was an officer, but I was sure I could pull it off, as I didn't want to embarrass the French officers. The French troops were all lined up at attention on the parade ground, waiting for my inspection and approval. I walked solemnly up and down their files examining their polished buttons and opened rifles, with the French officers trailing in my rear. I pulled it off because I had seen the same scene played out in a movie. Oh, if they only knew!

From there I was driven through San Sabastiene and Hendaye to the mountaintop in a convoy of three Citroens, to meet with the Spanish border guards on the heavily

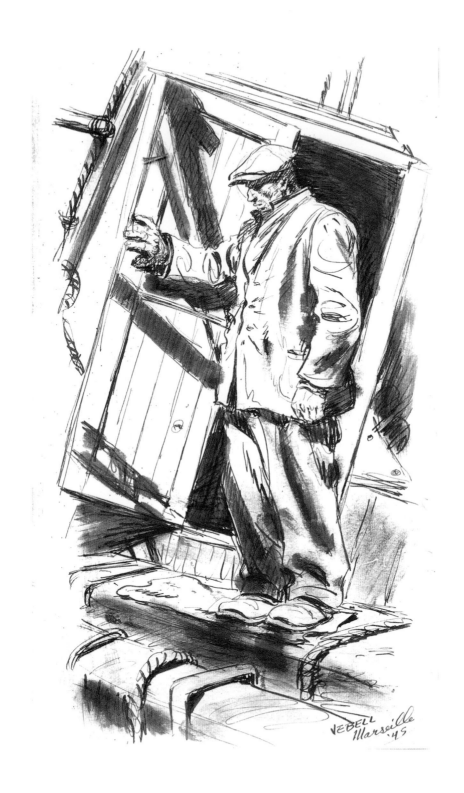

Sketch of a seaman in the port of Marseille. The port was heavily damaged by the departing Germans in the hopes of making the port unusable by both the French and Americans. 1944.

France

guarded "no man's land" strip between the two countries. The Spanish soldiers had what looked like German uniforms, but with Spanish insignia on their collars. "Viva Franco" had been painted in bold letters on the side of the wooden guardhouse on the Spanish side of the border, plus a few German helmets nestled against its wooden frame. One French officer explained in Spanish what the was purpose of the two American journalists. The Spanish sergeant in charge immediately invited George Dorsey and myself to partake in a tour of Spain. We had to politely refuse the offer since the US Army would have listed us as AWOL, with the addition of jail time. I took photos, plus later made one of my best paintings of the war in color, of the group of French officers plus three of the Spanish border guards. They all posed on the strip of "no man's land" between the two countries.

On descending in the Citroens from the mountaintop, I was in the lead car with the ranking French officer driving. He casually asked me if there was anything I would like. There are moments in life that one would like to have kept your mouth shut. Without thinking, I said "you know, I haven't had a glass of milk since I left Chicago." We continued descending, and all of a sudden, he signaled to the other two cars and swerved into a side road, which led toward a rustic farmhouse nestled in a valley. The farmer came out and, after a very brief conversation, we all went into what should have been the farmer's living room, but with the exception that there was now a cow living in the middle of it, which was quite common in the countryside. After some argument, I suddenly started to realize what was happening. The farmer sullenly milked his cow into a glass and handed it to me. I desperately tried to refuse it. But to save face for the French officer, I took one sip of the hot milk and handed it back. A most embarrassing event I would like to forget.

On returning to the base of the mountain, George and I met with the Republican Spanish officers in a hidden away, primitive hut. George did his interview and I sketched the occupants, who were the veterans of Spain's Civil War, still carrying their wounds and missing limbs. On returning to Marseille, while descending the mountain's narrow twisting curves, we lost all the bottles of good French cognac we had accumulated. A grievous loss! *Yank* magazine published all my drawings of our rendezvous with the Spanish border guards.

Stars & Stripes transferred its main operation back to Nice, France, where I resumed my daily illustrations of the war news and events. On occasion I had to work as a photographer, which led me to photograph Gen. Charles de Gaulle giving a speech on a balcony in Nice in 1944. Years later I had to photograph him again, and this time I got a big smile from him. I think he remembered me from when we were together on that balcony in Nice.

Since I was still continuing my fencing training, I was asked to participate in a fencing exhibition with the fencing master of Nice in the sports velodrome. Before we went on, he asked if I would let him beat me, as he feared for his reputation if an amateur American triumphed over a professional French fencing master. I remember the judges cheating on the scoring, so he didn't have to worry.

Whenever I could find time from my busy schedule of illustrating the war, as the dispatches arrived I would borrow a jeep from the motorpool and drive into the low range mountains coming up from the shores of the Mediterranean, looking for picturesque scenes to paint. The reputations of the small villages of southern France are well deserved. One could buy a small villa overlooking the Mediterranean Sea for $1,500 in 1944. My favorite village was Haut de Cagnes, where I returned again and again. There I met Heleyne Berton. She invited me to spend the night at her home, which was perched high on a hilltop overlooking a deep valley. It was a spacious impressive home and was tastefully decorated with Arabic furnishings. Her father had been an architect, which would account for the artistic atmosphere. The house had originally been a monastery in a previous life. Heleyne told me that since the house was isolated, and on top of this high elevation, it could be used as a safe house for the British RAF pilots who had to ditch their planes and parachute down. She then said she had something to show me, and asked me to follow her. We proceeded to file down the hillside about 500 yards below the house, where she parted some bushes and revealed an iron grating with a still operating gate, which covered the terminus end of an escape tunnel. It was just big enough to crawl through. It was originally dug by the monks to escape from the wars between the Italian Duchies and France, and was still being used in World War II as a safe house for downed pilots.

Heleyne had a sad tale to tell about her younger brother, who had secretly been working for the local French Resistance. The German SS caught him and he disappeared. Heleyne went to the SS headquarters in Nice to beg for information. Being an attractive young lady, the commanding SS officer promised to look into the matter and help her. She was chauffeured around town in the officer's touring car for all the residents to see, which would not bode well for her after the war. But he played her along in exchange for her favors. Unfortunately, her brother never came back, in spite of all her searching. She also told me of being stalled on a train while crossing over the wide Rhône River as the RAF was unleashing an aerial bombardment on the bridge. The elderly gentleman seated next to Helyne received a hit and the top of his head landed on her lap! The tales of the civilian casualties of the war were repeated a million times over, and I felt Heleyne had a right to present a sad face to the world.

Shortly after, Heleyne and I, along with Joe Brignolo, one of the two staff photographers on *Stars & Stripes*, were seated on the terrace of a newly opened restaurant. It was a converted chateau on the top of Haut de Cagnes, with a large open terrace, now decorated with a string of paper Chinese lanterns (later this same chateau became the Picasso Ceramics Museum). The restaurant at the time was void of diners except for us, and one other very attractive young lady dining all by herself. As my future wife often said, "I had no shame." I went over to the table, introducing myself, and asking if she would like to join us, especially thinking of Joe, who lacked a dinner partner. She accepted, and as we made the proper introductions, she announced her name was Denise Renoir. I immediately thought, "oh my God! She must be Auguste Renoir's granddaughter."

She and Joe hit it off right from the start, and it was the start of a prolonged date of a full week. We were invited to the Renoir house, a cozy, nicely furnished country house: Americans would call it French provincial, but with original Renoir paintings decorating the walls—an especially nice one hung over her bed. Denise's mother, who was in attendance, received us rather coolly. At that point I found out the reason. Denise was already married to Claude Renoir, who was Auguste Renoir's son. Claude Renoir was up in Paris absorbed in making movies and neglecting his young, pretty wife in southern France. This was a normal scenario for most French husbands. Once they were married, a mistress soon followed. After a week passed, I got nervous about being declared AWOL and drove back to Nice; I got back to work, while Joe stayed longer.

Jump forward almost sixty years later. I received a phone call from Joe saying: "Hey, Ed, do you still have Denise's phone number?" He was going to visit Haute de Cagnes, and try to find her. I hope he was successful. It would make a great love story!

BILL MAULDIN AND *UP FRONT*

Closing shop in Nice and moving northward in army trucks on the Route Napoleon, with the Alps Mountains on our right, we arrived in Grenoble. We requisitioned the offices and printing presses of the Grenoble newspaper *Les Allobroges* in August 1944. Along with my daily illustrations, I sometimes worked as a photographer. This time I was assigned to do a story on the French First Army pursuing the German Army from the tops of the French Alps Mountains. Got good photos here!

We took over a French hotel to house the staff. Bill Mauldin's reputation had grown so far that he had just received a contract from Henry Holt & Co. to do a book on his life, with a collection of his cartoons, for which he would later receive his first Pulitzer Prize. He showed me his check of $5,000 as an advance on royalties. Now he had to produce a book! All through the war, with Bill and I sharing a two-man art studio, he never fooled around, in fear of his wife Jean learning of it. We had double dated a few times in Naples, Italy, but it was all very platonic. This time it was different. Here at the offices of *Les Allobroges* newspaper worked two very young and pretty secretaries. One was chosen to come up to Bill's room to share in his good fortune with the book contract. He brought the young lady up to his room, which was adjacent to my room where Lysiane and I slept. The two of them holed up for a solid week. Food was brought up daily for them, but they never came out. We could clearly hear the typewriter clacking, with alternating sounds of the bedsprings squeaking, that went on all day long. I guess all that sex was inspirational, for he finished his book in one week. The completion of the book garnered Bill his first Pulitzer Prize! Bill must have changed the young lady's life because a few months later, when I was now in Paris, who should I see walking toward me, but the same young lady all rouged up, swinging her purse with a large floppy hat on her head and a short skirt. We exchanged pleasantries, and I pretended I wasn't aware of her change of lifestyle. She still looked like a pretty seventeen-year-old.

EXECUTION OF FRENCH COLLABORATORS

While in Grenoble I witnessed and photographed an execution of seven young French collaborators staked out against a factory wall. The firing squad was French militia that had formed in a semi-circle to hold back the civilian crowd. I placed myself about fifteen feet from the first target. It was an unnerving scene to see the bullets plowing through their chests and hitting the factory backup wall behind them. The far young man, although hit, was still very much alive, with his head up, staring at the approaching French officer, and unholstering his belted pistol, which in turn was placed between the eyes of the slumping young collaborator for the *coup de grâce*.

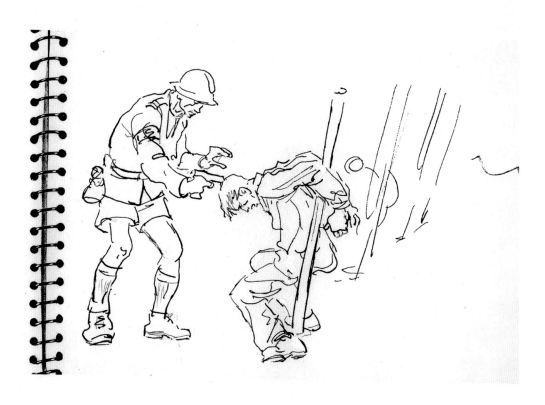

This sketch was executed on the spot, showing the French officer giving the *coup de grace* to the not-quite-dead young man, upon which the surrounding crowd of townspeople, mostly women, burst through the restraining cordon of police and proceeded to curse and kick the dying men. Crudely made, sawdust-filled pine coffins were immediately brought in, wherein the still dying men's bodies were dumped.

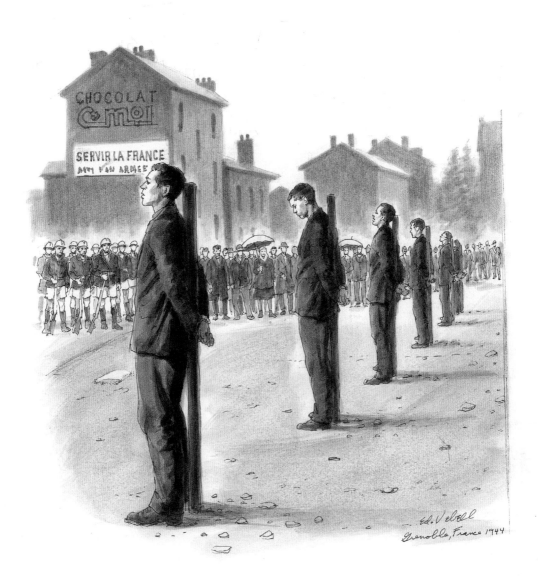

On September 4, 1944, in an empty lot in the center of Grenoble, France, the French FFI gathered to execute six young men tried and found guilty of treason by collaborating with the Germans. Being very close to the rifle fire, and with the rain falling on my sketch book, I found it very difficult to record the scene on the spot with much detail. So, this version was recreated in the studio.

54

Crude wooden coffins were brought in, and their bodies were quickly dumped in the sawdust filled coffins. At the same time the crowd of civilians broke through the line of militia, rushed up to the dying young men, and started to curse and kick them; it was mostly women doing the cursing and kicking.

With nervous hands, I tried to alternate between sketching and photographing the scene, but raindrops were falling on the drawings, which added to the somber scene. I felt I was not being very professional. I later had to recreate the scene from memory in artwork back at my drawing board.

ARRIVING IN PARIS

After the Liberation of Paris, *Stars & Stripes* moved their operations into the third floor of the Paris-Herald Building on the Rue de Berri. On the first day I arrived in Paris I climbed the long steps leading to the top of Montmarte and walked to a guard rail, which gave me a stunning view of Paris spread out in front of me for the first time. My response was a big "wow!" I fell in love with Paris—even wartime Paris. It stayed with me all the rest of the years. I came pretty close to making it permanent!

Bill Mauldin also came up from Grenoble to share our two-man studio. *Yank* magazine moved in on the floor above where they kept a small staff. Howard Brody was their staff artist, who did a magnificent job of covering the war. I was so envious of his freedom to go back and forth searching out frontline stories, while I had to wait for an assignment to go to the front.

Stars & Stripes took over a French restaurant, which had just been vacated by the German press corps. I guess the rationale was that if it were good enough for the German press, it would be good enough for the American press. The cooks and waiters just changed hats, so to speak, switching to English, and no longer serving Weiner Schnitzel.

It was amazing and gratifying to see and partake in what the French cooks could do with the flow of American rations. There was always a stream of celebrities and USO showpeople dining there, even at very late hours. Again, Lysiane was included for food rations at the restaurant, and was counted as just another GI on the roster of *Stars & Stripes*. She landed a job as a chorus girl at the Folies Bergère, due to her great body. She had been brought up in a convent and only vaguely knew of her father, who had been an actor in the B level French cinema. There was never any mention of a mother, who was probably unknown.

I rented a front room within a beautiful eight-room apartment at 2 Place du Theatre Francais, but with the stipulation that I wouldn't bring any young ladies in late at night for a sleep over; models posing for me during the day were ok. My window gave me a nice view of the front door of the Louvre just across the Place. The high ceilinged apartment had originally been a private French-German bank. I can only surmise that the owner had been of Jewish origin, as he fled for safer shores when the Germans entered Paris. His mistress, Mdm. Goepper, told me in confidence that he had left her

a million francs in a small bedroom safe in the apartment. I never thought to calculate the conversion rate at the time. She took the money and changed the rooms to more of a residential purpose. It was all very attractive, and even included a Polish maid. My rent was to be two dollars a month. Hard to believe! Since rents were so cheap, Lysiane and I rented two more apartments, all in the same price range.

One I remember fondly: It was quite romantic, even though it was a third floor walkup—a one-room studio apartment with no electricity. We had a bed, an old-fashioned kerosene lamp, a two-burner stove, and a tiny room just big enough to house a tiny washbasin. Each night at the Folies, Lysiane had to cover her nude body with body makeup, and each night on returning to this apartment on the north side of Paris, I would have to scrub her body down with a tiny sponge of about one inch square. We would squeeze into this tiny washroom and Lysiane would stand there with her arms upraised. I would start scrubbing her nude body down with this tiny sponge. I started from the top working my way down, but I could never get below the Mason-Dixon line. I couldn't stand it; I just threw in the sponge, and would push her on the adjacent bed, and make love. It was too much for a twenty-three-year-old young man to resist. This apartment was owned by one of the showgirls in the Folies Bergère. Years later I had occasion to return to Paris and the Folies, where the same showgirl proved to be the matured kid sister of one of the girls I knew in 1945. She took me back to the same old refurbished apartment. But now it had electricity and was nicely decorated.

PHOTOGRAPHING THE FOLIES BERGÈRE

Each evening after finishing work at *Stars & Stripes*, I took the Metro and got off at the Cadet Metro stop, which was close to the stage back door of the Folies. On entering I would sit and chat at the table of the concierge Mdm. Allery, where all the workers and the girls would sit, and have a glass of wine between acts. The presentations were called "*Tableaux*," which were quite artistic, with layers upon layers of nude girls with strategically placed costume pieces on their bodies. The full orchestra played excellent classical music to accompany the elaborate productions. The comedy acts were always well received.

Lysiane had worked her way up the ranks and was now titled "*premiere nu*," first nude. She generally had only three doves as a costume.

From the concierge's office I would wander backstage with my camera, a Rolleiflex, plus an Exacta 35 mm camera. Enveloping myself in the withdrawn folds of the stage curtain, my view of the show ran lengthwise down the stage. Sometimes I would climb in the rafters above the stage for a different viewpoint. All the performers loved to pose, with or without their clothes. No one was bashful! Up in the dressing rooms, my presence was fully accepted as part of the scenery. The girls would use me as a father confessor, to give advice on handling their love affairs, especially when it was with a GI. I pretended I knew what I was talking about. What did I know at that age? I got to

know the owner, Paul Derval, and Michel Gyarmathy, the choreographer and costumer, along with Fred Roy, his lover and lead male dancer. All the stagehands were friendly, but Lysiane always referred to them as "the communists."

CAUGHT IN A VICE RAID

After the first year, Lysiane took on an additional job as a dancer when the Folies let out at around 10:30 pm. This was at a Russian nightclub called The Scherazade Club, near Place Pigalle, the center of Paris nightlife. Each night the Metro subway system shut down at 11:00 pm. We couldn't easily get back to one of our apartments, and since rooms were so cheap, I rented a room on the third floor of a hotel nearby, which I surmised would be temporary.

After only a few days of evening use, we were dropping off to sleep, in spite of the bed being surrounded by mirrors, including the ceiling, when I heard heavy boot steps coming up the stairs. Then a pounding on my door! I answered back in French, then a loud voice saying, "Oh, there's a Frog in there!" The pounding footsteps receded going to the floor above, with a lot of banging on doors and loud voices in both French and English. We were falling off to sleep, when both the loud sound of boots and voices returned descending the staircase. Again the banging on our door, but this time I answered in English, which brought on an explosion of pounding on the door and yelling in English to "open the damn door." As soon as I complied, three military police and two French gendarmes burst in, demanding that they were taking my lady companion away to the police station. Lysiane was sitting up in bed with the bed sheet pulled up to her chin, looking terrified! I stated, "No, you are not." The French gendarme turned to me and said in French "do you know this lady"? I retorted, "of course, she is my *petite amie*," which in French means we are living together. His attitude completely changed as he called off the rest of the police to leave. I heard him say "*ah, c'est l'amour.*" Only in France! I never thought I would be a recipient of a vice raid!

ARTISTRY OF THE FOLIES

One evening I decided to buy a front row ticket to see the Folies show, as would a tourist in the audience, instead of my usual viewpoint from the wings. Not only impressed by the artistic presentations of the acts and tableaus, I saw Lysiane with the stage lights on her, full front, and in her scanty dove costume. I thought, "oh my God," and I got to go to bed with this beautiful vision every night! I never forgot that moment! I still have the ticket from my front row seat. One of Lysiane's best friends at the Folies was a statuesque beautiful chorus girl of Russian background named Olga. I took many pictures of her. A few years later there was an article on her in *Life* magazine, where the French government was awarding her the Legion of Honor for her service as a spy for the French during World War II.

France

LIFE IN WARTIME PARIS

Since there wasn't any public transportation after eleven o'clock, I didn't mind walking the deserted unlit dark streets of Paris between our apartments late at night. But there was still life in the bars and cafes. There was always the pleasant sound of the accordions playing the "*bal musette*," of which I was very fond. Nothing had changed since the "Belle Epoque" period of Paris of the early 1900s. In the fall there was always the pungent smoky smell of roasting chestnuts emanating from the vendors' street stalls. Since there was practically no gasoline for civilian use, the chestnut shells were put to good use. The French Citroen cars were outfitted with an ingenious burner mounted on the passenger side of the running board, burning the shells, which propelled the car. Again the smell of roasting chestnuts! During the winter, heat was hard to procure in a civilian building unless you had a coal-burning stove.

took a short course in lithography at the renowned Beaux Arts School during the winter. The nude model posed next to an ancient convoluted designed stove that fascinated me. I was more interested in the stove than the model. It would have been difficult to paint the model in color, because her side next to the stove was red from the heat and her opposite side was blue from the cold. So I photographed her and the stove for future use.

BEAUX ARTS BAL AND BASTILLE DAY

Once a year the students and models from the school would take over the Champs-Elysees, marching up the boulevard with linked arms and nude breasts toward the Etoile. The bare-breasted female students would break ranks from the marchers and would run over to the café seated onlookers who were having an aperitif or a glass of wine at their outdoor tables. They would filch their drinks with one gulp and reciprocate always with a *merci*, then return to the parade of dancing students. The final destination was nearby, which was Salle Wagram, a large, multi function dance hall. This time a huge pile of straw had been mounded up in the middle of the floor for the use of sex by the revelers. It was an unforgettably wild party!

The same could be said of Bastille Day. It was a non-stop marathon of street dancing, which lasted all night long and into the wee hours of the morning. With the dawn coming up, you could very well end up in a completely different quartier from where you started. We were fortunate to have strategically placed apartments scattered around Paris. None were more than $2 a month, which I could easily afford. The pay for the showgirls at the Folies Bergere was about $50 a month, which was true for an average worker in Paris. A dinner in a restaurant at the end of 1945 was $1, and a bottle of wine was fifty cents, but by 1946 the same dinner was now $1.50 and bottle of wine was $1. The amount of work demanded from me from *Stars & Stripes* started to ease up until I only averaged one major illustration a week.

ILLUSTRATING FOR FRENCH MAGAZINES

I started working for French magazines and newspapers—Eeen a French adventure comic strip. This last, I found too difficult to do, with the overhead balloons lettered in French. So I had to give it up after a couple of months. I work fast, so I was able to do at least two illustrations a week, which paid $50 each. All my illustrations had to depict a pretty girl as the major interest. Since model agencies didn't exist in France in wartime, I had to frequently use Lysiane and myself, using the self-timer on the Rolleiflex.

Often, at times, and in desperation while needing a model, I would stand in the doorway of my studio apartment looking up and down the street until I spied a pretty girl. On approaching, I would explain that I was an artist and in need of a model. Even if they were carrying groceries or whatever, they would come right up to my studio and pose for the scene. I got the impression that the French consider posing for an artist as an honor and love doing it. In one instance, the model, with an expectant look, asked "don't you want something more?" It would have been too embarrassing to explain that in renting my studio/bedroom from Mdm. Goepper, we had a handshake deal that I wouldn't bring in young ladies for sexual pursuits. Only legitimate models for the sake of art were okay.

Mdm. Goepper lived alone in the other seven rooms of our mutually shared apartment, except for the elderly Polish maid, who had a bedroom in the attic. My high-ceilinged room was spacious and modern, with a balcony overlooking the Place de Palais Royale, and a view of the front main entrance of the Louvre. My rent remained at $2 a month for years. Like all civilian buildings in wartime Paris, they were unheated, and water for a bath had to be heated on a stove. As a result, Lysiane and I shuttled between our other three apartments, mostly to be together, and for convenience. They were all so cheap that you could abandon them at will. A couple of them were cast-offs from the girls in the Folies, who were either moving on, or just wanted someone to take them over temporarily. It was better to have them occupied than empty, as the French officers would take them over and probably trash them without paying the rent.

One story that I remember well, and would never be a subject for a newspaper article, was about one of the more mature girls at the Folies. Lysiane had to stay over at her apartment one night for some reason. What she related the next morning, with wonderment, was this woman had a separate business apart from the Folies. She hired out as a sex teacher for the young sons of wealthy men of Paris. The rationale was that the boys were going to start to experiment on their own anyway on reaching puberty, and if so, they might as well be taught from a professional. Lysiane told me of the clinical book the lady kept, describing all that transpired between them for the three days and nights required for the course. She didn't mention the price paid by the fathers. All I could think of was what a bestseller this book would make, as I am sure that all these young men are now running the French government.

I still have to admire the French practical view of the world. I don't think Americans could ever emulate this way of thinking. I also noticed that there weren't any racial barriers in French society during World War II. Intermixing of the races was common.

It was easy to see why Josephine Baker chose to stay and work in France rather than the United States. When I met and photographed her in Algiers for *Stars & Stripes*, she came across as a very warm hearted, fun-loving person. She performed at the Folies Bergère just before the war broke out, so I missed her presence at the Folies by several years. She returned to the Folies in 1948 for her final engagement, but I had already left for the US and missed her.

TRAINING FOR THE COMING OLYMPICS

When I finally arrived in Paris and got installed along with Bill Mauldin in our two-man studio operation on the third floor of the *Paris-Herald* building, I found time to start fencing again, this time at Salle Bourdon near Place Clichy. Maitre Bourdon was one of the best fencing coaches in Paris. Again I took advantage of the food shortage in Paris and paid with a can of Army meat ration of Spam each week. This went on for the next two years. I didn't think of it at the time, but I am sure I was the only American soldier training during wartime for the next Olympics. I could now train with the very best French fencers, which is what I needed most.

I bouted a lot with Adrien Rommel, who became the champion of Paris in foil. Even with these training bouts, he steadfastly refused to acknowledge a hit against him. It never failed to annoy me. It seemed to be a common trait among European fencers, especially when the opponent was American. Another fencer I had occasion to work with was Raoul Clery, who had been renowned as a top saber man. The story I was told was that the Germans had caught him and they had cut off his fingers diagonally across his hand. So he only had his thumb and little finger left to work with. But he could still do a commendable job with the blade strapped to his hand. I was impressed by him, not only as a good fencer, but also by his genial personality.

One large difference between French fencing Salles, and their American counterparts is that the French fencing Salles commonly have a small bar tucked away in a corner of the room. So the sweaty French fencer can always have an invigorating nip of his favorite wine or aperitif between bouts. This helps the French fencing master augment his income. I noticed one older fencer making frequent trips to the bar between bouts. He came back to where he had left off on the fencing strip, got "on guard," and slowly keeled over onto the floor. What struck me was that he still maintained his "on guard" position on the floor. He seemed to be in a petrified state from the alcohol and was carried off by sympathetic fencers. I benefited greatly from Maitre Bourdon's lessons.

THE WAR IN EUROPE WINDING DOWN

In December 1944, the Germans gathered all their resources and counter attacked, driving back the Allied lines in France, which became the famous "Battle of the Bulge." Suddenly, all unessential personnel were disappearing and being sent to the front to check the German onslaught. I thought surely I would have to become an infantryman, but the fact that I was

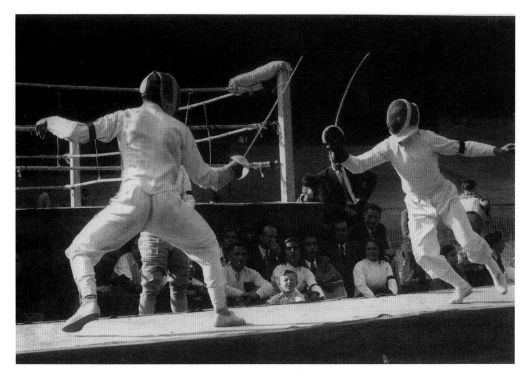

I received a request to put on a fencing exhibition with the professional fencing master of Nice, France, to be held at the Velodrome of Nice. The author is at left, with Maitre Tornatore on the right. We fenced both saber and foil. 1944.

the only professional artist on the staff of the Paris *Stars & Stripes* kept me from filling a gap on the front.

In Italy, the one attempt to have an alternative artist to fill in ended in disaster with our newly embedded artist Gregor Duncan, being killed on his first assignment, on the beachhead at Anzio, Italy. *Stars & Stripes* never tried again to fill his shoes. So I was spared, as I was the only artist on the staff in France. Of course we had Bill Mauldin, but he concentrated on his feature cartoon each day. Bill and I shared a studio on the third floor of the Paris-Herald building on the Rue de Berri, just off the Champs-Elysees. He was often missing, as he had permission to roam the front in his personal jeep to get ideas for his cartoons.

The Rue de Berri was interesting, as when you turned into the street from the Champs-Elysees, immediately on your left was the famous and prestigious art school The Julian Academy with a narrow walk up of four floors of studios. It had been closed and neglected during the German occupation. I temporarily considered buying the building and was able to search out the two spinster sisters who were the present owners. I can't remember the price, but I wish I had gone through with the deal, even though the fourth floor glass skylight was broken, allowing the rain to enter and warp the floorboards of the fourth floor. The pre-war student paintings were still stacked against the walls of the classrooms.

Next to the Julian Academy was the café/restaurant of Django Reinhardt, the famous Gypsy jazz guitarist who played nightly to an overflowing audience. It was impossible to

get in, due to the jam up at the street entrance. The New York-Paris Herald building came next, which housed the English language *New York Herald*, plus *Stars & Stripes* on the third floor, and the *Yank* offices on the fourth floor. Next door came the Shell building, where I holed up for two years after the war. Lastly came the famous world class cooking school, The Cordon Bleu. It looked closed and unoccupied, probably due to the lack of food during the war.

ROLLEIFLEX CAPER

Marty Harris, our staff photographer, kept his cameras in our studio on the Rue de Berri, as we could lock our door. Marty was a witty and fun loving guy, as well as one of my best friends. He made a practice of unashamedly asking every female he would meet for sex, and he confided that ten percent would say yes, which is a good average, especially when he was quite homely. When he saw a pretty young girl, he always wanted to meet her mother, figuring and hoping the mother was being neglected.

He also had a larcenous streak. He was planning and waiting for the Germans to retreat through the town of Braunschweig, Germany, which housed the Rolleiflex camera factory in the middle of town. With the price of a Rolleiflex camera in Paris surpassing $700, Marty was planning a raid on the factory.

As the American troops rolled through the town, Marty had commandeered a truck and driver and waited just behind the first wave of American soldiers, pushing the retreating Germans down the street and past the Rolleiflex factory. With rifle smoke still filling the street, Marty entered the factory, with two very scared German workers still on the premises. In Yiddish, he ordered them to pack up all the undamaged cameras that were still on the premises and put them in the waiting truck. The total was three very large crates painted in field gray and with nailed down tops. The jubilant Marty turned the truck around and headed back to Paris. What a haul! He was about to make a killing!

With Paris being a two-day return trip, they had to look for a convenient stop over. They happened upon a Supply Depot en route, where they decided to spend the night as guests. At dinnertime Marty couldn't resist recounting the tale of his coup at the Rolleiflex factory, and about the three crates of cameras stored in the back of his 2½-ton truck. This was a huge mistake. In the middle of the night, his rapt audience had pried open the lids of the crates and stole most of the contents of each crate, and then carefully nailed the lids back down; they looked as they had been untouched. The escapade was undiscovered until they arrived back in Paris. To make matters even worse, the remaining cameras had originally been packed in separate crates without their hinged backs. This made them almost useless for resale.

This problem brought in Alex Schoura, a French photographer, who had attached himself to the art department of *Stars & Stripes* from our previous tour in Grenoble. He acted as a "go between" with the French civilians and *Stars & Stripes*. He helped out as an unpaid translator for all the deals being cooked up. Alex went to work for Marty, and finally got rid of the incomplete cameras.

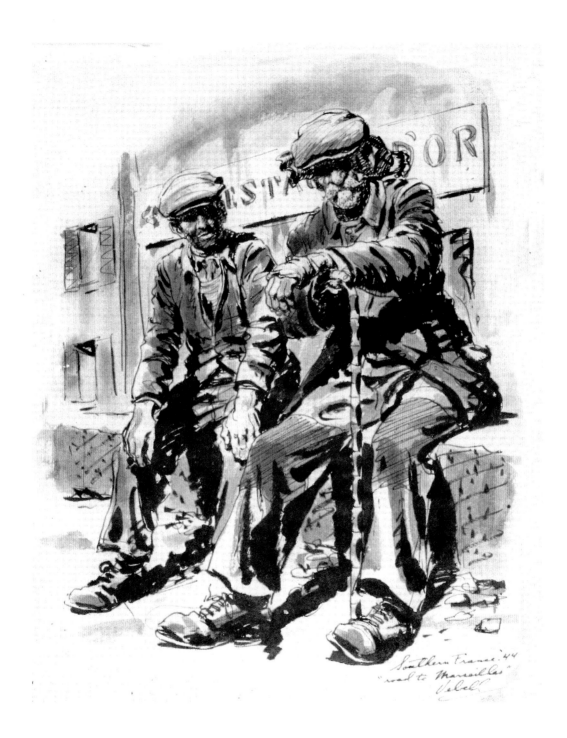

Two character studies of small town French citizens, sketched on the road to Marseille. The first love for an elderly Frenchman is to immediately switch to the subject of conversation to politics; especially with a conversant American. 1944.

France

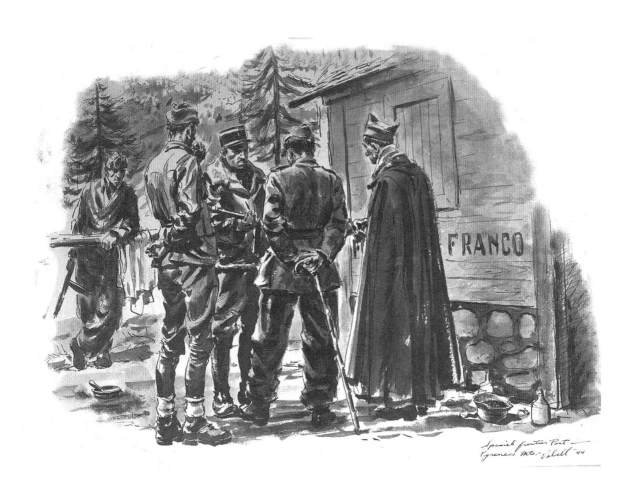

Recording a meeting between the only French military garrison in southwestern France and the Spanish border guards in "no man's land" between the two countries, on the top of the Pyrenees. 1944.

Small spot drawing of the devil whispering to a demoralized and dejected battleworn GI. Illustrating a poem in *Stars & Stripes*. 1944.

France

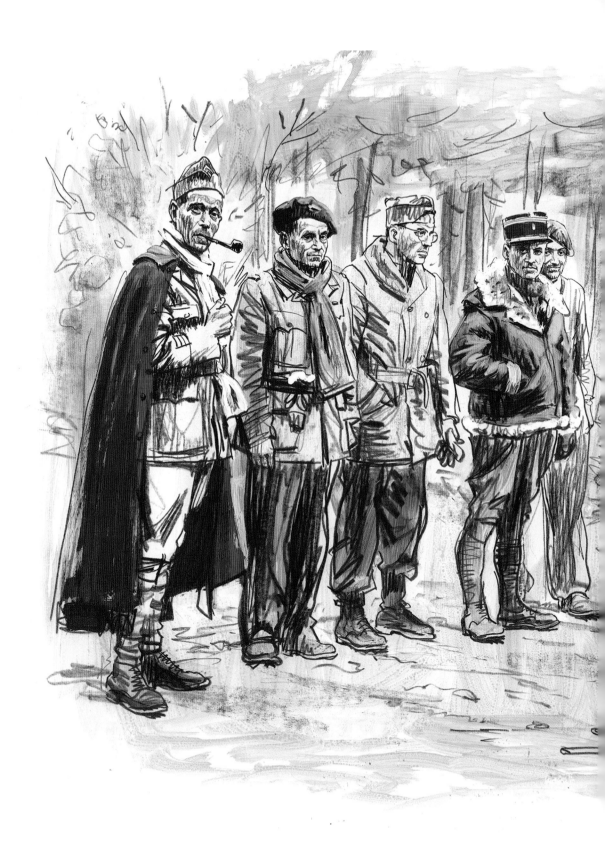

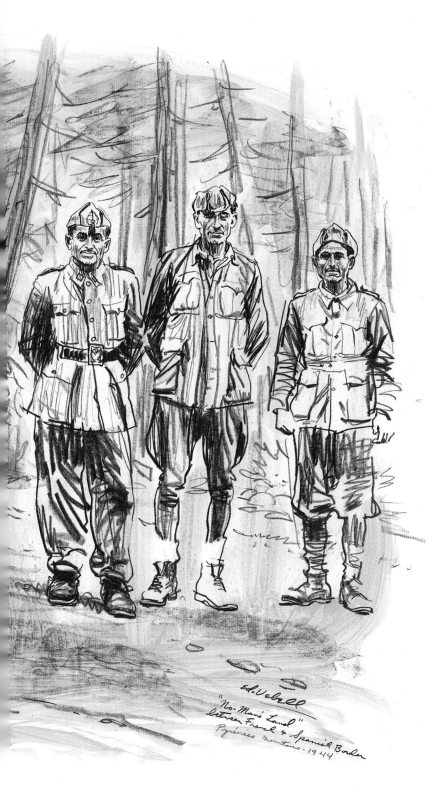

Ed.Vebell
"No-Man's Land"
between French & Spanish Border
Pyrénées Mountains - 1944

Another sketch from the meeting of the French officers and Spanish
border guards in reworked German uniforms and helmets. 1944.

France

Carnival traveling show of strong men and wrestling acts in the city of Toulouse, France.
Note the drum used to bring attention to the enticing acts within. 1944.

Another view of the street carnival in Toulouse, with the barker urging
the onlookers to come see the wondrous acts inside the tent. 1944.

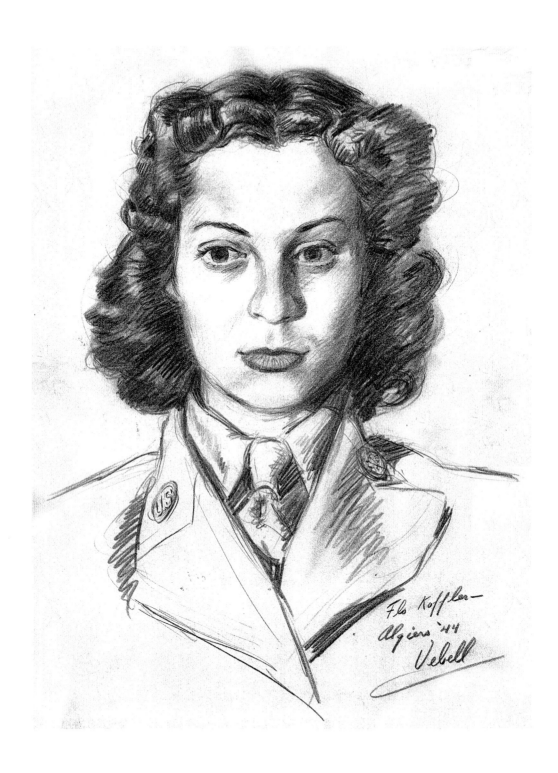

Pencil portrait of WAC Cpl. Flo Koffler. Our paths crossed several times during the war. In spite of her posing in the nude, I believe our relationship was platonic, for some unfathomable reason. Flo really taught me how to pack a barracks bag.

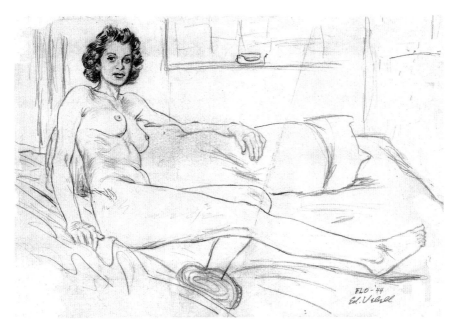

Sketch of WAC Cpl. Flo Koffler in the nude. I am quite sure that this is the only existing drawing of a WAC during World War II sans clothing. As you can see, she was a healthy looking young lady.

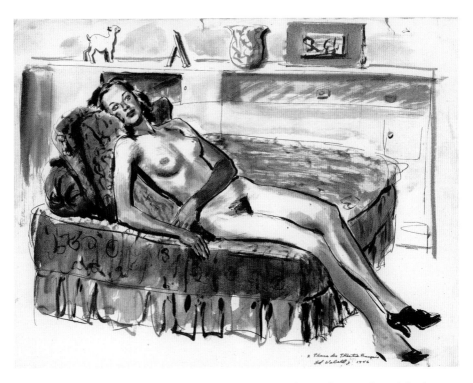

Ink and wash drawing of a young lady recruited from the street in front of my studio, while she was grocery shopping. She was flattered to be asked to pose, and thought surely after being paid, she would have to do much more than just pose in the nude.

France

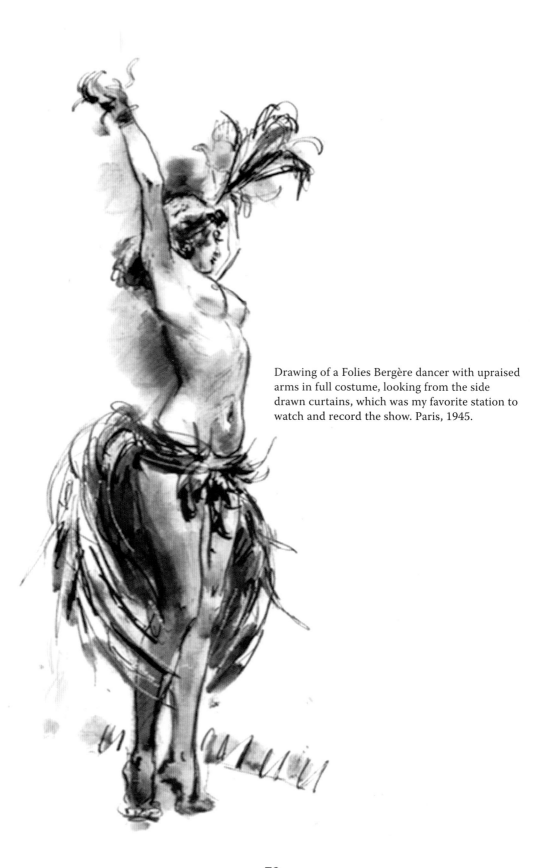

Drawing of a Folies Bergère dancer with upraised arms in full costume, looking from the side drawn curtains, which was my favorite station to watch and record the show. Paris, 1945.

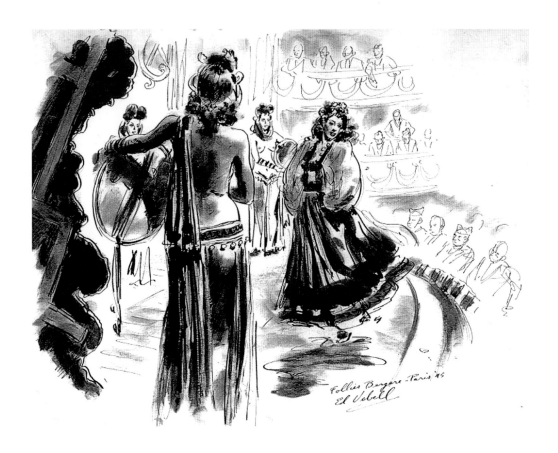

Another sketch from the vantage point of looking from the drawn folds of the
curtain, across the stage of the Folies Bergère. This was published in *Stars & Stripes*
as a double page spread. Paris, 1945.

France

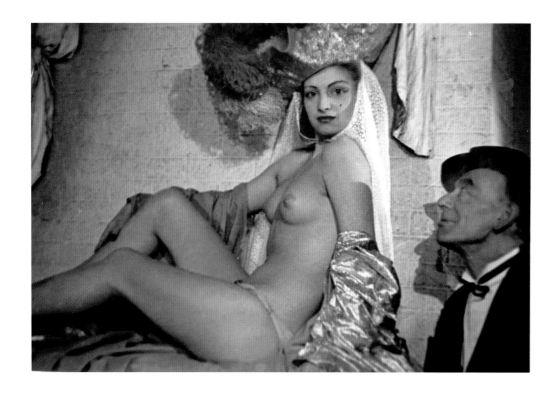

Lysiane Heraud, my companian of three years, posing with Dandy, the slapstick French comedian backstage at the Folies Bergère. Lysiane was awarded a well deserved title of "*premiere nu*" due to her great body! Dandy performed in countless acts of burlesque as a hapless victim! Paris, 1945.

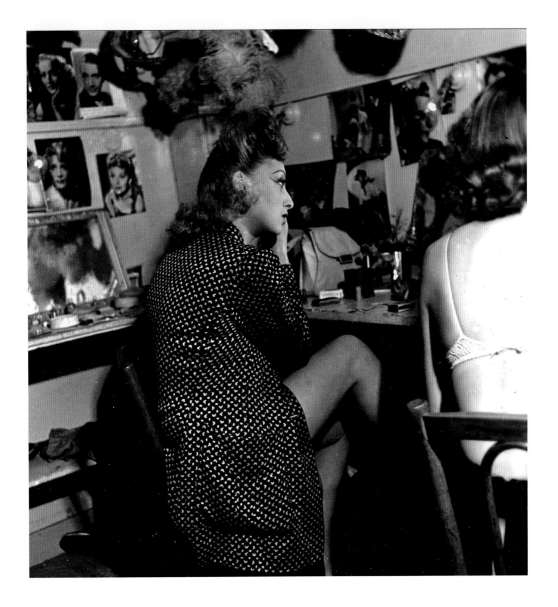

Lysiane in the Folies Bergère dressing room making up in preparation for the next elaborate show, which was usually a spectacular display of nudity mixed in with classical music and comedic sexy skits. All very professional and artistic. Worth the price of the ticket! Paris, 1945.

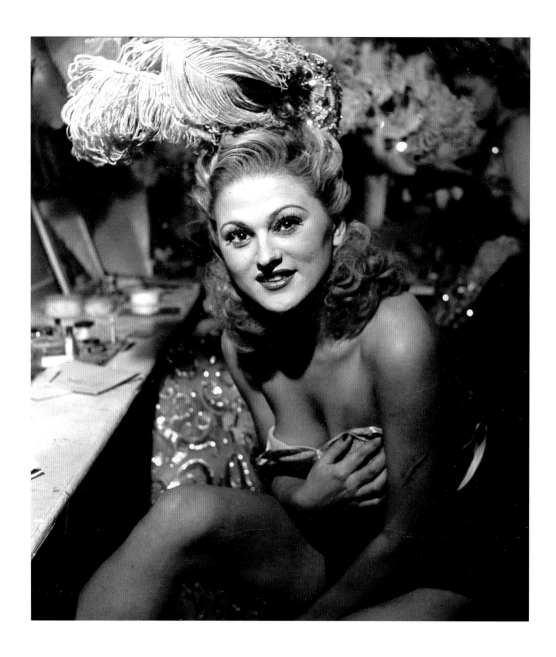

Closeup of Olga, a Russian émigré at her makeup table. She was one of Lysiane's friends. In 1948, she was awarded the French Legion of Honor, for her service as a spy during World War II. *Life* magazine published an article about her deeds and the presentation. Paris, 1945.

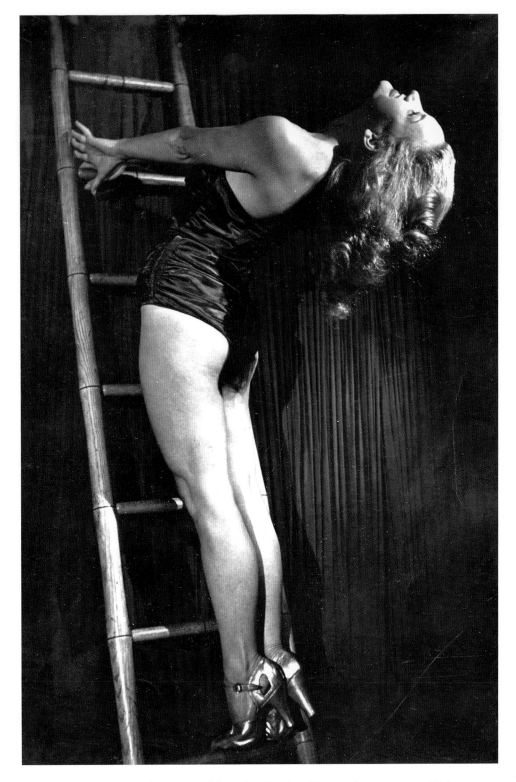

Ginette Wander, the versatile vocalist of the Folies Bergère. Her vocal range spanned light opera to more contemporary fare. She was small of stature, but possessed a great body and an instinct for dramatic posing! A pleasure to work with. Paris, 1945.

France

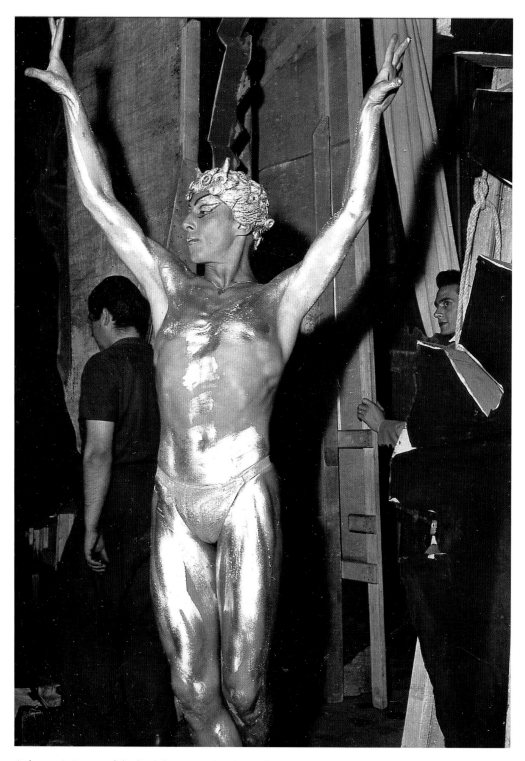

A dramatic image of the lead dancer in the classical presentation of *"Apres Midi d'une Faune"* with his body encased in a silver metallic paint. A striking display! Every one at the Folies made extensive use of body makeup. Paris, 1945.

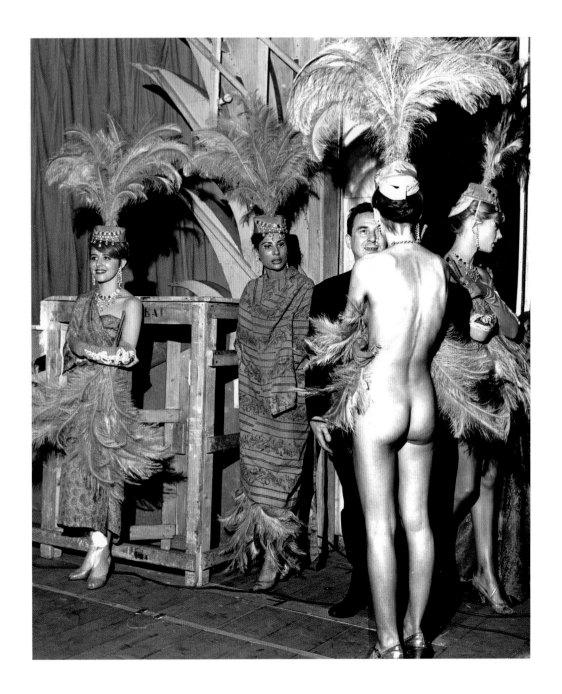

Folie's girls backstage, waiting to appear on stage. Note the elaborate headdresses and the normal lack of cover for the showgirl's backside. No one was ever modest and loved to show their bodies off. A boon to an artist or photographer! Paris, 1945.

France

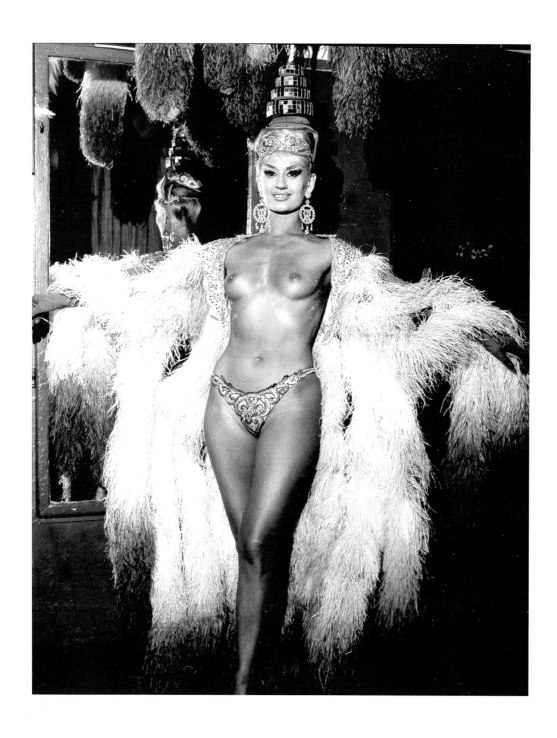

This Folies showgirl is from 1963, shown here during my return trip to Paris. Never asked for her name, but I called her "Super Girl" for obvious reasons! One of the showgirls turned out to be the now grown-up kid sister of one of the girls from 1945–46. A family tradition! Paris, 1963.

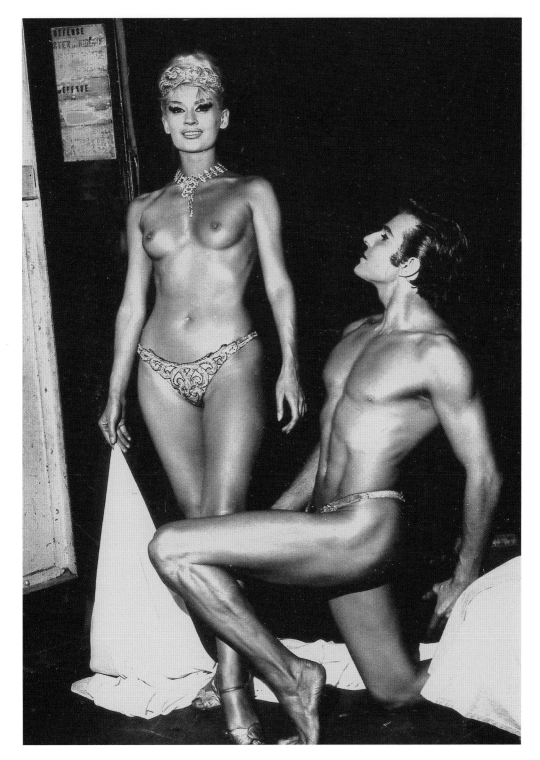

One more photo of "Super Girl" and her male dance partner. They look so great together. I use the term dance partner loosely, since all in the cast had to have great bodies. Their only requirement was to move around gracefully, and show it all off when the lights went on! Folies Bergère, 1963.

France

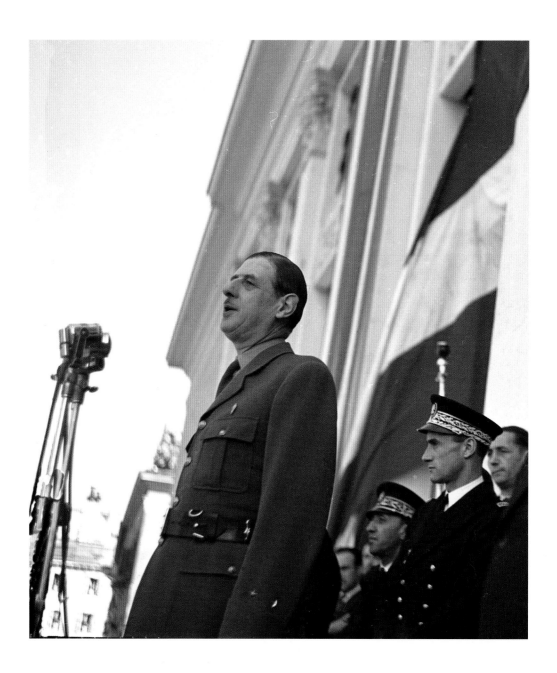

Gen. Charles de Gualle on a balcony giving a speech to the residents of Nice, France. I didn't pay attention to the contents of the speech as I had to concentrate on my photo coverage. However, our paths crossed many years later at the International Air Show at Orly Airport. This time I received a big smile; I think he remembered me as the GI photographer on that balcony in Nice in 1944.

Two French prostitutes moonlighting as artist's models. Note the hairdo. Nice, France, 1944.

France

While in the southwest corner of France, we stayed overnight in the town of Lourdes, where one is compelled to record the famous grotto, with its history of miraculous recoveries. 1944.

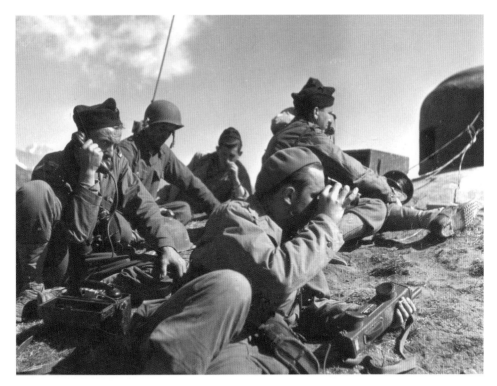

Men of the First Free French Division in a command post atop a height on Mt. Aution ridge, directing fire on German positions half a mile away. Note the latest American equipment. 1945.

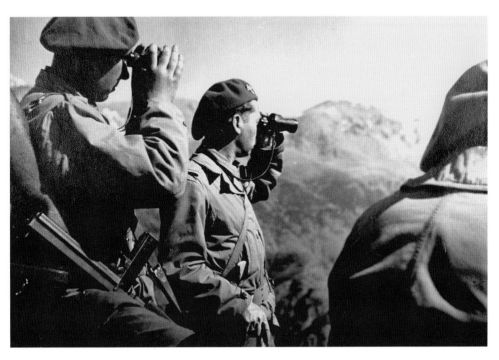

Observers of the First Free French Division checking the results of their artillery fire on German positions on opposite mountaintop. 1945.

German sergeant taken prisoner and being questioned by an interrogator. Glad to be out of the war, he insisted he hadn't surrendered. He knew all about the Allied success in Germany and the Russian entrance in Berlin. 1945.

The three most prominent American photographers of World War II. From left to right: Carl Mydans of the *New York Times*; Slim Arons of *Yank* magazine; and George Silk of *Life* magazine. All momentarily together for a group shot on their way towards Genoa, Italy. Found in my "war files." 1944.

France

A grandfatherly looking Cossack patiently posing for the *Amerikanski* artist to record his presence, just after the fall of Berlin. He reminded me of my own grandfather from eastern Europe. Berlin, 1945.

4

THE WAR'S END

Russians Occupying Berlin

In spring 1945, the war was winding down and I was sent to Berlin to do sketches of the Russians occupying Berlin; this was about ten days after the battered city fell. What struck me most on arriving was the absence of Russian tanks. All rolling transport seemed to be done in horse-drawn farm wagons and a few captured German civilian autos. The city of Berlin was a mountain of rubble and collapsed buildings. The only livable housing was in the suburbs, where a requisitioned house was being used as sleeping quarters for the press corps.

I roamed the center of the city with a sketchpad and camera to record the remnants of Berlin. There were bucket brigades of German women in long lines, going up a mountain of rubble and handing down the broken stonework, bucket by bucket. I wandered over to what was left of the Reichstag building. In the rear and on ground level I found the doorway to Hitler's bunker. The descending steps were strewn with impassable masonry and pitch dark. Without a flashlight, it would have been impossible to explore. On top of it, we were always warned about the mines left by the retreating Germans. All I could record was two stripped-to-the-waist Russian soldiers washing their shirts in the still-intact small garden pool that Hitler had installed just outside of his bunker. Next door I photographed the bombed out bowels of the Reichstag, where the Russians had scribbled their names on the walls and on the huge bomb-scarred pillars supporting the building.

From there was a short walk to the Reich Chancellery building, where an unexploded aerial bomb had crashed through the roof, descending three floors below, and lodged in the basement unexploded, leaving a large, fifteen-foot hole exposed in the middle of the three floors. For some unknown reason an armed Russian guard was posted on a chair next to each gaping hole. The spacious hallways were lined with marble walls, with a Nazi eagle over each doorway. Everything of any value seemed to have been looted. However, I entered the nearest office on my right, which proved to have belonged to *Reichsminister* Joachim von Ribbentrop. His office desk had been overturned, and his calling cards were strewn on the floor. I grabbed a handful and stuck them in my

pocket and left. Over the years I lost most of them, but I managed to preserve one card. In my wanderings through the streets of Berlin, I met a German female doctor, who finding out I worked for a newspaper, told me about their fears of the Russians invading the city, which were well founded. Most of the women of Berlin had evacuated to the south, mostly toward Bavaria. She told me of the Russians going through any apartments still standing, searching for any females. Very young or very old, it made no difference, they were pulled out and raped on the spot. She was now treating the victims for cases of syphilis and gonorrhea.

The black market scene was thriving on every street corner, and especially in the Tiergarten next to the still standing Brandenburg Gate. The Germans carried briefcases and bags with their personal valued possessions, hoping to swap or sell for food or cash. The Russians, as well as the Americans, were eager to make a deal. I had a hard time convincing the Russians I was not trying to sell the two cameras hanging from my neck. I photographed these scenes, which *Life* magazine published.

LUNCH WITH THE RUSSIANS

Back at the press quarters in the Berlin suburbs, I teamed up with two other correspondents to try to get eastward into Russian territory as far as we could go. One correspondent was Belgian, who of course spoke French, and the other was Turkish, and also spoke decent French. This gave us a common language between us. The Belgian also spoke fluent Russian, by grace of rigorous training in a military language school. So we felt well prepared. However, the Turkish writer behaved oddly, as he was always brushing off his uniform with a brush in his pocket. As it turned out, he confessed that he had been caught in bed with *Herr* Goebbel's right hand man's wife. This garnered him a six months stay in a concentration camp. On his release, he had what I would call a case of the "cleanies." If he went outside, and upon reentering, he had to brush himself off again and again.

We got a press jeep and a British driver and took off early in the morning, passing under the Brandenburg Gate eastward, which was now Russian territory. After two or three hours driving, we spotted a Russian encampment in a field on our left. It was around noontime, and we thought we would ask for something to eat. Upon pulling into the field, the Belgian conveyed our request in his best Russian. I'm sure that this was the first contact that this group of Russians ever had with any westerners, especially me as an *Amerikanski*. Before we could sit down, there was immediately a call from the Russian commanding officer that we must have lunch with him personally. His command post and quarters was a commandeered farmhouse on a slight rise. We were ushered into the dining room of the farmhouse and seated at a rough farm table, with bottles of schnapps and vodka in front of us. The schnapps was for drinking with the meal of sausages and potatoes, and the vodka was for toasting the victorious Allied armies. The Russian colonel (or he could have been a general, as he wasn't wearing his tunic, so I couldn't see his rank) called for his personal

accordionist, whom I sketched, to be seated on an adjacent couch and play patriotic Russian tunes. Jokes and stories had to be told and translated in two languages, which resulted in delayed laughter after each story.

An odd thing was when a white-jacketed orderly with a very bad limp came out at the beginning of the meal to lay out the dishes. It was startling, as before each guest he leaped into the air, pirouetting in a full circle, while balancing all the dishes on the other arm and bringing down each plate with a slap to the table. It was explained that he had been a well-known ballet dancer before being severely wounded on the Eastern front. Now one leg was quite a bit shorter than the other. In spite of his handicap, I guess he wanted to demonstrate to the western journalists that his prowess as a ballet dancer was still there. After choking on the powerful drinks, we filed out of the farmhouse to take photos together without the commanding officer, who stayed inside. I got the feeling that the rest of the Russians were only pretending to be friendly, as there always was an air of suspicion in the air coming from the Russians. I ended up with some good artwork. Two of my color drawings were purchased by the American Academy in Berlin. *Stars & Stripes* devoted a full page on my drawings, and I exited Germany via Templehof airport and flew back to Paris.

European War Over

The European War was over and I had recorded the jubilation and parades down the Champ-Elysees on May 8. My workload of daily illustrations for *Stars & Stripes* was cut way back to one illustration per week. I started working for French publications, primarily three magazines and one newspaper. They paid the equivalent of $50 per illustration in cash and I did about two a week. This wasn't too bad when a French dinner at a fairly decent restaurant was one dollar and a bottle of wine cost fifty cents.

Lysiane was always asking me for more money. Then she confessed that she was giving it away to some of the girls at the Folies who were down on their luck and needed money. I realized then that I was supporting women that I didn't even know.

Bill Mauldin disappeared from our two-man studio, and I was on my own again. One embarrassing moment of my life in Europe occurred when Lysiane showed up after hours at my studio on the third floor of the Paris Herald building. It was after six o'clock and all the *Stars & Stripes* staff had already left for the US, leaving all the offices on the third floor empty, except for my lone studio. My request for a military discharge was immediately granted. I needed my rent-free studio space to now work for the nascent French publishing industry. It was turning dusk, and I had turned on my strong desk lamp on my cluttered drawing table in the rear of the studio. I had also taken the proper precaution to pull down the overly large front window shade spanning the width of the studio room. Bill Mauldin's newly emptied sturdy drawing table was against the front window. Lysiane and I decided to have sex on Bill's uncluttered drawing table. Who would ever know! I then thought I heard a strange sound coming from the street below. I cautiously raised the bottom of the shade to

peer into the street. To my surprise, the almost dark street below was now filled with at least fifty or more citizens and soldiers. They all started cheering and shouting, "bravo, bravo" and "encore, encore" over and over. I suddenly realized that our images had been projected on the closed shade at least three times life size from my desk lamp for the entire world to see! Even the opposite facing building "Le Hotel California" was filled with WACs cheering from their hotel balconies. Lysiane and I dropped to our knees and crawled out of the room in embarrassment. All the while Lysiane kept muttering *"vous est fou,"* *"vous est fou"*! Many years later I was invited by the French military to participate in the 300th anniversary of the French hussars. I couldn't help but pass by my old address on the Rue de Berri and photograph the window from the street and found that the shade was still drawn!

NUREMBERG WAR TRIALS

My last good assignment for *Stars & Stripes* was to cover the War Trials in Nuremberg, Germany. I didn't realize at the time, as a twenty-two-year-old kid from Chicago, what an important part of history I was about to witness and record! At the time I only thought of it as just another job. Early in the trials no cameras were allowed, and I didn't realize that my drawings were going to be unique, as being done from life "on the spot." Later on, that rule was rescinded and cameras were allowed. I wasn't allowed to interview any of the defendants and had to work from the press gallery, which was at right angles to the prisoner's dock. I was close, but not close enough to zero in on the faces. I used a borrowed pair of field glasses, a Waterman sketching pen, and a small sketchpad. Thank God I was a good draughtsman and was able to pin down the various personalities in the first dock, in spite of their constantly moving heads. I didn't have any water, so I spit on my finger to get halftones. I concentrated on Hermann Göring, as he was the closest to me. His stripped down uniform looked too big for him, as he had lost considerable weight, but he looked like a man "still in charge." Next came Rudolph Hess, who kept his head down, absorbed in a book; I had to wait until his head came up to get a likeness. Wilhelm Keitel was next in line, and after that I did less detailed sketches. I also recorded the lawyers and judges, plus the prison guards. I think I did a good job, especially working with an unforgiving fountain pen; there was no room for errors! The press was quartered in the Eberhardt Faber (pencil tycoon) mansion which had musicians playing violins in balcony alcoves, perched above the dining room where we ate between breaks in the proceedings. After three days I was finished and roamed the streets of Nuremberg. I recorded the bread lines and the population walking with their heads down in dejection after losing the war. It was a cold, gray November in 1945.

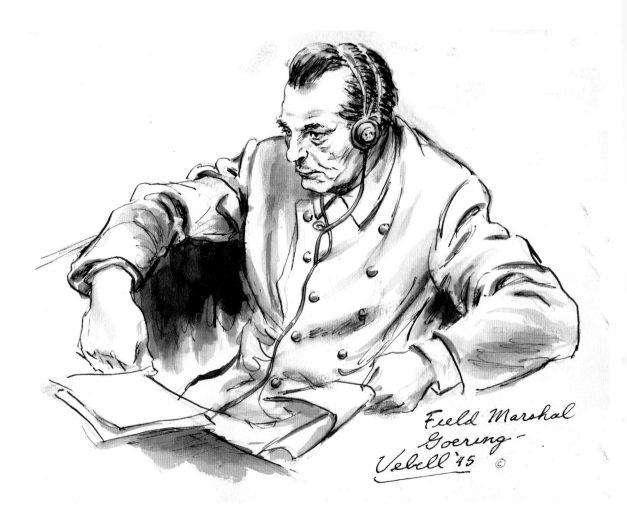

Field Marshal
Goering-
Vebell '45 ©

Drawing from life of Hermann Göring during the early stages of the Nuremberg War Trials in 1946. Cameras were banned at the beginning of the trials but permitted later on. The drawing was done with binoculars to close up on his features, and I used an artist's fountain pen, with spit to get halftones, as I had no water. Göring's uniform sagged, as he had lost considerable weight in prison, but he looked like he was still in charge.

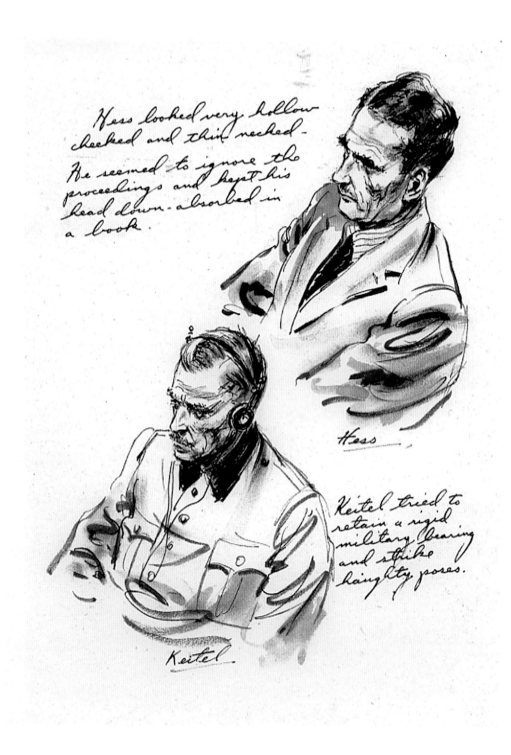

Hess looked very hollow
cheeked and thin necked -
He seemed to ignore the
proceedings and kept his
head down - absorbed in
a book .

Hess

Keitel tried to
retain a rigid
military bearing
and strike
haughty poses.

Keitel.

Rudolf Hess was next in line, usually followed by Wilhelm Keitel. Hess paid no attention to the proceedings and kept his face down, absorbed in a book, which made it difficult to do a portrait. Keitel always maintained his military bearing, as well as his distain for the judges and prosecutors.

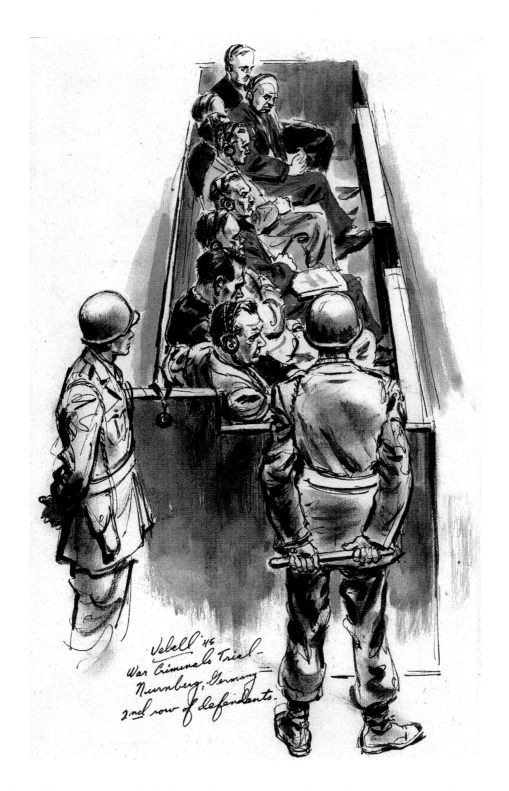

View of the second row of defendents and the American military police guards. As I only had limited time at the trials and had to equally cover all of the participants, I had to skip the top row and concentrate on the judges and procecutors as well.

The War's End

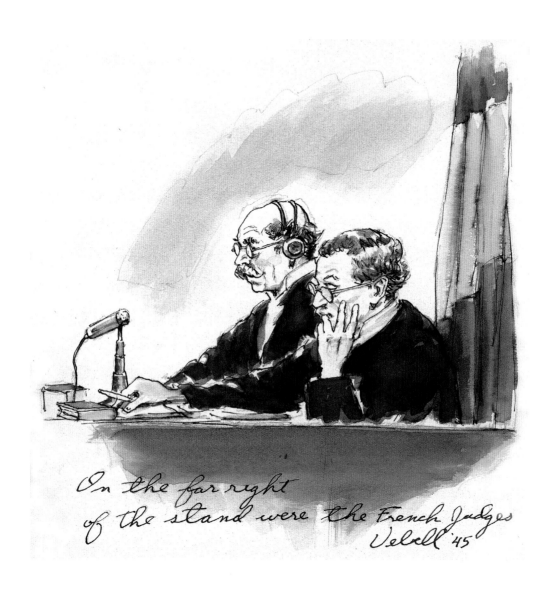

On the far right
of the stand were the French Judges
Velell '45

Sketch of the French judges, who had a scholarly and old world look that appealed to me as an artist. This drawing disappeared from the store room of *Stars & Stripes* and had to be redrawn later from a copy of the original printing in *Stars & Stripes* of the Nuremberg War Trials.

British Courier
for the Correspondents —
Uebel 45

I couldn't resist sketching this tough looking Scot's Guard courier for the correspondents standing, and unmoving at my left elbow. There were ten drawings in all, done with an unforgiving fountain pen, which left no room for errors. But I pulled it off, and recorded a bit of history at the age of twenty-four.

The War's End

a few studies of the German defense counsel—

The German defense counsel in various studies. My duties as an artist/reporter were to get a broad overall view and feeling of the Nuremberg Trials and proceedings, and look beyond the prisoners to get a wide-angle view.

the German
defense counsel –
they were immediately in front of the
defendants –

The German defense counsel was seated directly in front of my viewpoint. They felt that the Allies as victors were making up the rules as the trials proceeded. They also doubted their legality.

The War's End

Spectators at War Criminals Trial
Nurnberg, Germany - Vebell '45

Sketch of various war correspondents taking notes for their respective worldwide
newspapers. Photographers were barred until late in the proceedings.

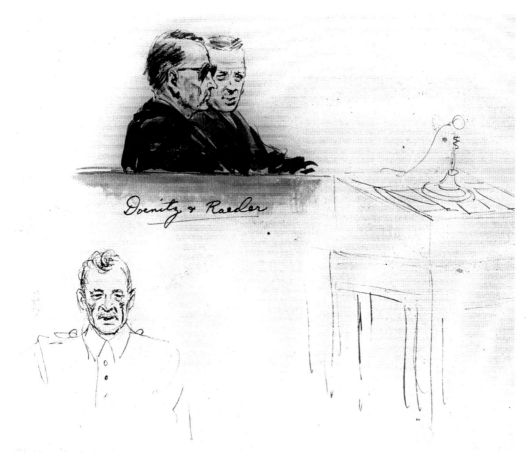

Quick sketch of admirals Karl Dönitz and Erich Raeder. Dönitz commanded the entire German navy at war's end. He was called the "Rommel of the Seas." He served a ten-year prison sentence and died in 1981. Raeder was commander in chief of the German Navy. He hoped to be shot instead of being sentenced to hang. He was sentenced to life in prison.

My ID card for the Nuremberg Trials.

The War's End

Falling from the Swiss Alps

Back in Paris I resumed my work for the same French publications, mostly for *Reves* (Dreams). They kept me busy with "boy-girl" illustrations, as *Stars & Stripes* was shutting down and everyone was leaving for home, with a few exceptions. Capt. Harry Cohen, a close dear friend, disappeared for a month to help out as an officer any way he could, in the founding of the new state of Israel. On returning, he and I decided to take a vacation thru Switzerland and then southern France.

What prompted the trip to Switzerland was hearing that the banks in Switzerland were giving out free money to any American soldier that showed up in uniform at any Swiss bank tellers window. It was a fairly substantial amount at the inception, about $200 I believe, but as the weeks passed the amount was shrinking. So Harry and I decided to cash in on the gifting before it stopped. We requisitioned a jeep and headed for Zurich in northern Switzerland. Sure enough, we stopped at the first bank we saw in Zurich, but the amount had now dropped to about $125. Since it was free money, we didn't quibble and thanked the teller and left. Switzerland had wisely kept out of the war and was now loaded with cash, and wanted to reward the American soldiers for their participation. I don't know if the British were offered the same deal.

From Zurich we headed south, crossing into the Swiss Alps, with a brief stop at a monastery. They had a sign out on the road announcing the sale of Kirshwasser. Of course we had to purchase a few bottles. This was the last day of September, and we were on the very top of one of the mountains, with the sky turning pitch dark, and the snow starting to come down in huge flakes. I drove a little further and then lost complete sight of the road and surroundings. Thank God I stopped and got out of the Jeep, leaving the headlights on, and trudged through the already deep snow, because about fifteen feet dead ahead of my bumper was a sheer drop that disappeared into a void of darkness. At that moment I heard something that sounded like a human voice, like a faint "Hallo" with a bobbing light approaching. It came closer and proved to be a Swiss mountain ranger with a lantern in hand. He had seen my headlights in the dark. He explained that we should follow him to a slightly higher elevation, which was the very top of the mountain. There we found a huge barn-like structure, which proved to be a Swiss mountain ranger station. On entering, I saw about twenty rangers already bunking down for the night, with no electricity; only candlelight and lanterns. Our new found friend hurriedly explained that his fellow rangers were now there for the winter and did not expect to get down the mountain until next spring. However, if we left immediately, we might have a chance to descend the mountain. We climbed back into the jeep and he pointed out the direction to go, yelling "*bon chance*"!

Sure enough, after a few minutes as we descended, the snow thinned out and the twisting road started to appear, as we sighed with relief. At the bottom of the mountain, out of the darkness appeared a huge beautifully appointed hotel. As it turned out, it was their last day of their season and we were their only guests.

After a good meal and an equally good night's sleep, we woke up in the morning to an unforgettable sight of a glacier of ice framed through a huge window in the dining room. The glacier was the source of the Rhone River flowing through a quarter of France. I couldn't

resist jumping back and forth over the small rivulet that formed as a starting point of the river from the overhead glacier of ice. After a good Swiss breakfast, and the official closing of the door for the season behind us, we piled back into the jeep and headed south with the last snowy Alpine mountain range in our view. We kept climbing on a barely discernable road and reached the summit. All this time in the Alps, we had never seen another car or signs of habitation, with the exception of the ranger station and the valley hotel. We crested the summit and started our descent.

With Harry at the wheel and a snowy, icy, primitive road curving away thirty feet from the crest, we went into a slow motion skid and dropped over the side of the mountain. I never figured how far we fell, but it had to be quite a long drop. I know we turned over three times in the air, as my head hit the roof of the closed jeep that many times, along with the tire irons and the rest of the loose gear in the falling jeep. Down we went, without hitting anything on the way, until we landed on the snow-covered pine trees, cushioning us like a giant gloved hand, as we landed upside down in the deep soft snow. Harry crawled out first and managed to struggle to the front of the wounded jeep. He pulled out a camera, muttering, "no one is going to believe this" and took my picture crawling out of the other side. Now we were in a survival mode, concentrating on saving ourselves. The first step was to upright the jeep, and turn on the ignition. Lo and behold, the trusty engine started up! The four corners of the jeep looked rounded off but it ran. This time, I told Harry, "I'm going to drive, you walk ahead and you find a route between the trees, until we come out on a road." Then, my foot on the accelerator got the shakes from the shock of it all and for the next half hour our scarred jeep bucked uncontrollably, until we came out on a small rural road. We had survived! We kept heading south until all of a sudden there was the blessed, warm, glistening Mediterranean Sea. A memorable vacation I never forgot.

From Nice I revisited all my favorite villages on the Riviera and some previously overlooked locales. On the terrace of the Hotel Monte Carlo in Monaco, I photographed the resumption of the first open fencing competition in France since the German occupation. I saw Heleyne Berton for the last time, sitting alone at the bar of the Hotel Negresco. I'm not sure if she was looking for customers or not. So I hid behind a large plant and left. I didn't want to embarrass her.

Post War Paris

We headed back to Paris in the still running Jeep. A trip from Nice to Paris on the Rte. Napoleon could take thirteen hours, all the while scattering the same chickens en route. Paris was slowly coming back to life, restaurants opening in private apartments, and well-attended.

A large art gallery opened across the street from the Paris-Herald building. The first showing was of Marc Chagall's large paintings. It was a one-man show and the gallery was empty except for the owner and myself. I queried the asking price, and the answer was the equivalent of about $350. That was a lot of money in 1945, but oh, if I had only bought one! A Toulouse Lautrec original lithograph, along with a Derain or a George Roualt lithograph, could be had for $13 each. I declined a Delacroix for $18 as too much.

All American military supplies were being dumped or sold off at any offer. The quartermaster depot trucks parked in the small side streets, selling the contents and then the trucks themselves. *Stars & Stripes* closed their offices in the Paris-Herald building, and I was able to find an empty office in the adjacent Shell Building, which became my new studio for the next two years. I had meanwhile taken my discharge from the US Army and started a new life. Until there was a complete shutdown of all American military presence in Paris, I was able to keep wearing my uniform and keep my PX card for needed supplies.

Before *Stars & Stripes* completely shut down, I had two choice assignments: one was to record the very first unveiling of the first bikini bathing suit, which was presented in a matchbox and worn by a model in a bathing beauty contest at the Bois de Boulogne swimming pool. It was filmed and had world coverage.

The other was to photograph a bevy of very attractive USO girls, all in their bathing suits, on the grounds of a private estate on the outskirts of Paris. Needless to say, I got some great shots and forged a friendship with June Bright (a Hollywood starlet) that lasted for years after I got back to the States.

Sewers of Paris

Back in Paris, *Life* magazine wanted to do an article illustrating the recovery of Paris as a tourist attraction, with a story on the "Sewers of Paris," which had been on the pre-war tourist map. During the war the tunnels had been an escape haven for resistance fighters and refugees from the German occupiers. Many buildings had access directly to the sewers.

Joe Pazen, the *Life* photographer assigned to do the job, already knew me and asked for my help to furnish models to pose as tourists. The plan was to fill the quota with girls from the Folies, as they would be free in the afternoon, along with Lysiane and myself in civilian attire. The access to the main sewer was a plain street sewer with the usual iron cover pulled to the side. A ladder protruded from the opening in the street and a rather crude hand made sign for any possible tourists, announced the resumption of a "Tour of the Sewers of Paris." But alas, at the hour scheduled, it started to rain heavily and the girls from the Folies never showed up, except for Lysiane and myself. Ever resourceful and undaunted, I scanned up and down the boulevard for prospective recruits. I soon spotted a young Parisienne coming towards me, clutching a bag of groceries in one hand, and the other hand holding an umbrella overhead to ward off the now considerable rain. Running up to her, I quickly explained our predicament of needing someone to pose for a photographer. Her response was, "what will I have to do?" I said the first thing would be to climb down this ladder protruding up from this manhole in the street. After deliberating a few seconds, she said, "I don't think my mother would like that" and took off in the rain. In all my years in Paris, this was to be the first and only refusal to be a model I had ever received, and it was very understandable. So Lysiane, a city sewer worker, and myself were the only participants.

Joe did a good job of stringing flashbulbs at strategic points to illuminate his subjects. On descending the ladder we found ourselves inside a rounded white tiled tube about

fifteen feet in diameter, flanked by twin narrow walkways on each side. Water was rushing through the sewer length at a fast pace and deep enough to float a poled rowboat with no noticeable unpleasant odors. The only sound was from the unique message system of pneumatic tubes flanking the walls, wherein the department stores and banks could send messages and bank receipts between themselves.

I still have the photos, but *Life* never ran the article. My two closest friends were Lt. Harry Cohen and Sgt. Mark Hoffman, each married nice French girls and disappeared, and suddenly I was alone as an American in Paris for the next year and a half.

Backstage Life at the Folies Bergère

I settled down picking up Lysiane backstage at the Folies every night, but allowing time to take photos from the curtained wings of the stage or up in the dressing rooms. I got to know all the girls and their lives. They were all curious about Americans and their sex lives and I pretended I knew what I was talking about. I found out later that I had been supporting some of the girls without my knowledge. Lysiane had often asked me for extra money and then confessed up, that she had been giving money to some of the other girls in need . It didn't bother me, as I had been very busy working for numerous French magazines and doing very well as the only American illustrator in Paris at the time. The average wage for a French worker in Paris in 1945–46 was $50 per month, and I was doing two illustrations a week for $50 each. However, I managed to bring back a great deal of my art from *Stars & Stripes* and *Yank* for the eventual trip home.

New Studio in the Shell Building

The drawings I did for the Nuremberg War Trials survived, as I rescued them from being disposed, along with a stack of editorial art stacked against a wall in a small storage room on the third floor of the Paris-Herald building. Wartime news photos were also going by the way of the trash bin. Looking to the future, I anticipated their value as reference material for future war illustrations, so a select group was also stored away for my use.

I had done my last full page illustration for *Stars & Stripes* to celebrate the New Year of 1946, depicting the New Year 1946 baby banishing the God of War. That was my last job for the paper extending over the past three years; an unforgettable experience that changed my life forever.

All of the American military had packed up and left for home, leaving me quite alone, and adapting to my new French life. Luckily I had Lysiane and we settled in to her life at the Folies. Even with all the work I was creating each week for the French publications, I still trained for the coming Olympics at the Salle Bourdon. I considered myself as very fortunate to be able to seamlessly adapt so quickly. I wasn't aware until some time later that I hadn't spoken a word of English for the last year and a half! I think I must have had the honor of being the last soldier to leave France!

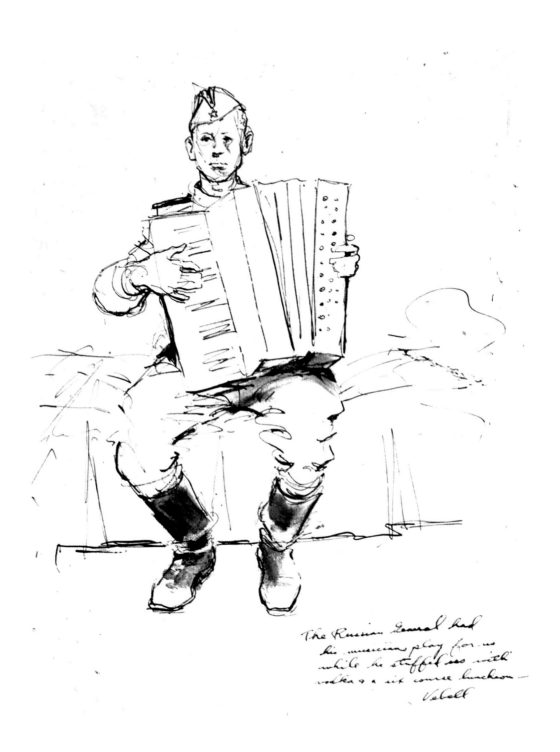

The Russian General had
his musician play for us
while he stuffed us with
vodka & a six course luncheon —
Veloll

Sketch of a Russian accordionist called in to perform while we were having lunch with a high ranking Russian officer. Lunch consisted of sausages and potatoes, with lots of vodka and schnapps, followed by multiple toasts to the victory of the Allied Armies. Russian Zone, east Berlin, 1945.

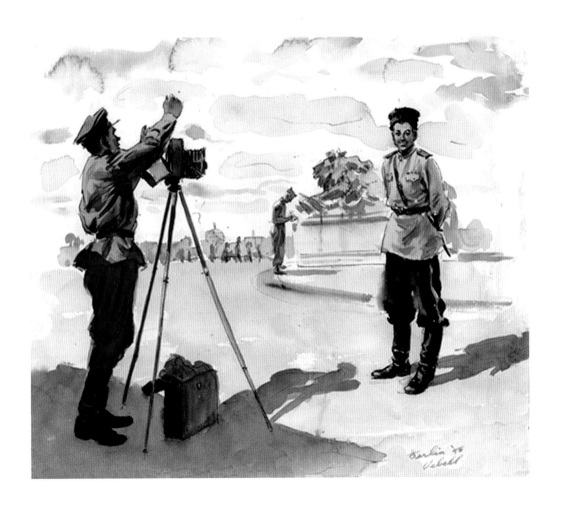

Russian street photographer already recording the Cossack soldier that he had " made it" all the way to Berlin! The photograph to be mailed back to family as proof. Berlin, 1945.

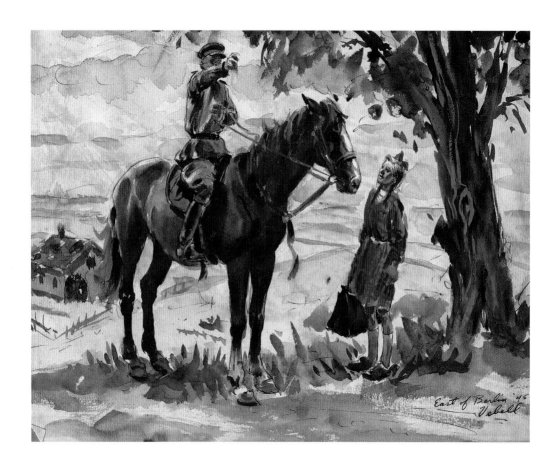

A Russian soldier on horseback giving directions to an obviously lost young German girl in east Berlin (Russian territory). Most young German girls had fled to Bavaria for safety.

Stars & Stripes illustration of a GI spotting that a German farmer had planted his trees in the form of a swastika. 1945

The War's End

Berlin street scene. The Russians struck me as being mostly short and stocky and poorly uniformed. They requisitioned every car in sight. I got the impression that they must have stormed the gates of Berlin by the wagonload and on foot! Where were the tanks? The street signs translate I believe to Potsdam and Frankfurt. Berlin, 1945.

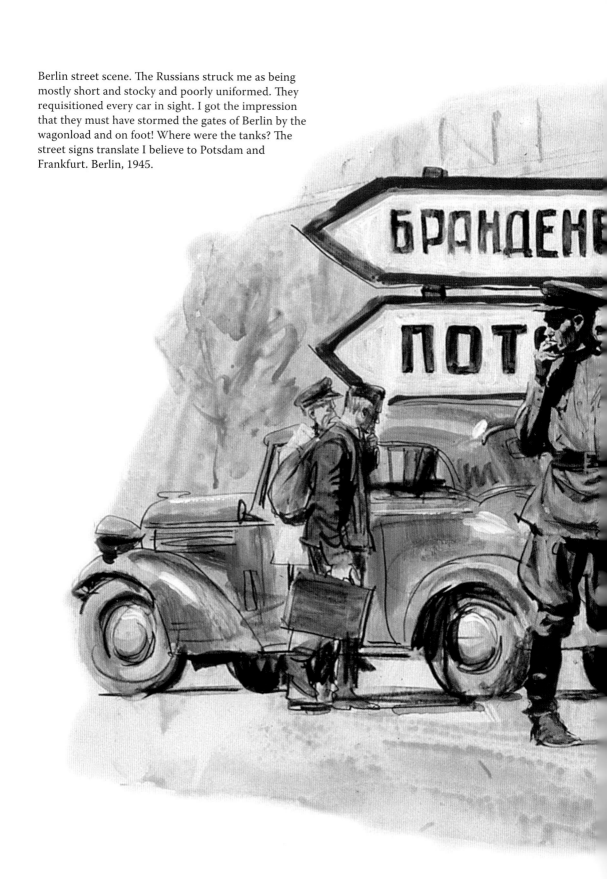

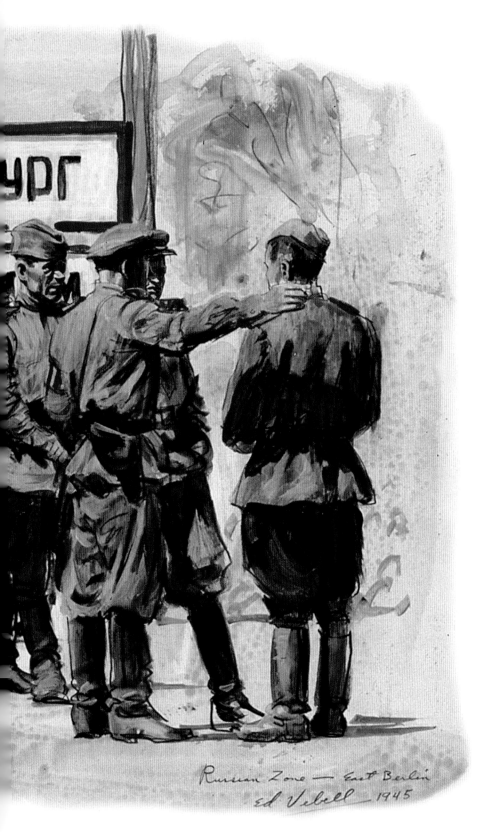

Russian Zone — East Berlin
Ed Vebell 1945

111

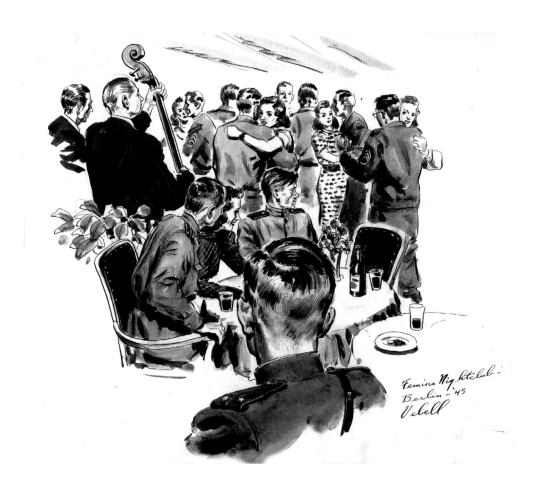

Russian officers enjoying the pleasures of the Femina Night Club
in Berlin by mostly drinking heavily, but not dancing, which was
mostly between the American GIs and the local *frauleins*. The
German girls preferred the Americans and avoided the Russians,
especially after the mass rapings of the women of Berlin.

Russian soldier examining a makeshift monument to a fallen commrade. Berlin, 1945.

The War's End

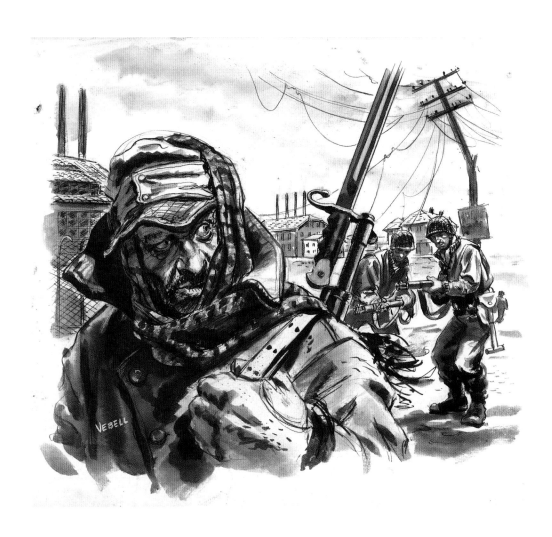

Stars & Stripes illustration of GIs capturing a German soldier at the end of the war. It is interesting to note that any depiction of a German soldier in my drawings had to show him in an unflattering demeanor. The same unwritten rule also existed in World War I art.

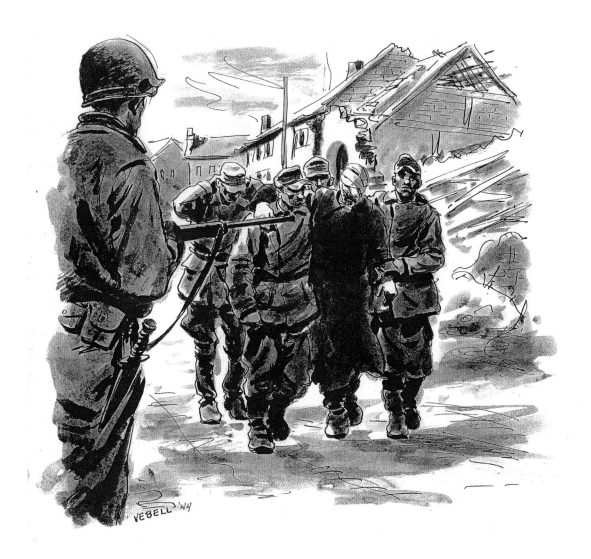

My last drawing for *Stars & Stripes* showing the daily surrender of the defeated Germans, thus bringing an end to almost four years of illustrating and photographing a bit of history for *Stars & Stripes*. An unforgettable run!

The War's End

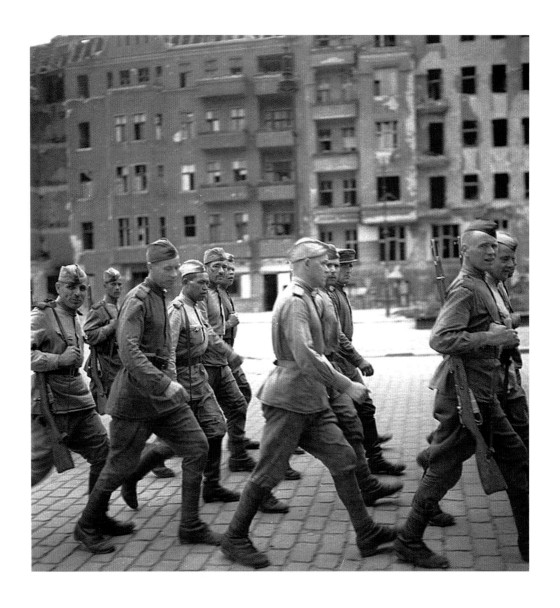

Russians marching in east Berlin. They seemed ill equipped and poorly uniformed. On leave they all seemed to have an insaitiable desire for Western made wristwatches. Berlin's Teirgarten black market was teeming with deals and participants.

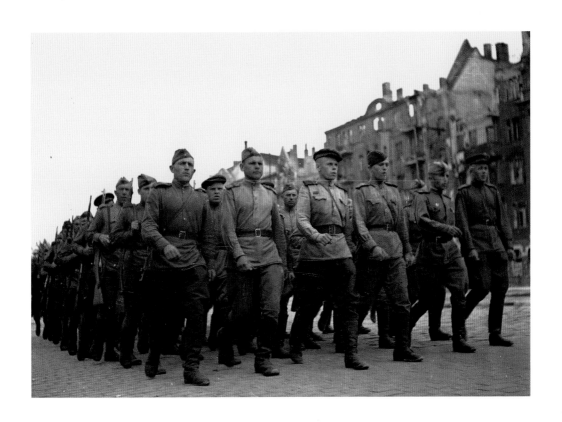

The War's End

Photograph of Russian soldiers passing under and through the heavily bombed Brandenburg Gate, which was the dividing line marking the four Allied divisions of Berlin. Note the angry Muslim Russian soldier shaking his fist at me for taking his photo, which is forbidden in the Koran. I had no idea! Berlin, 1945.

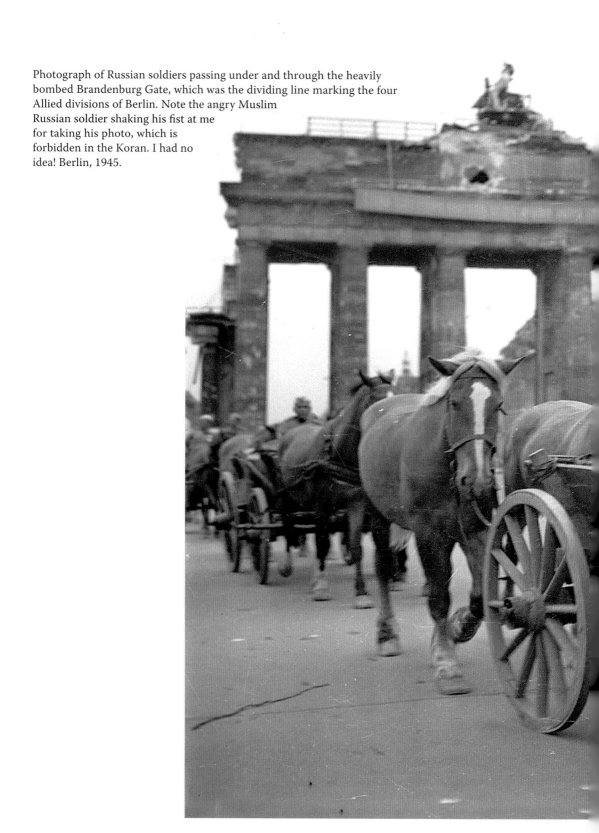

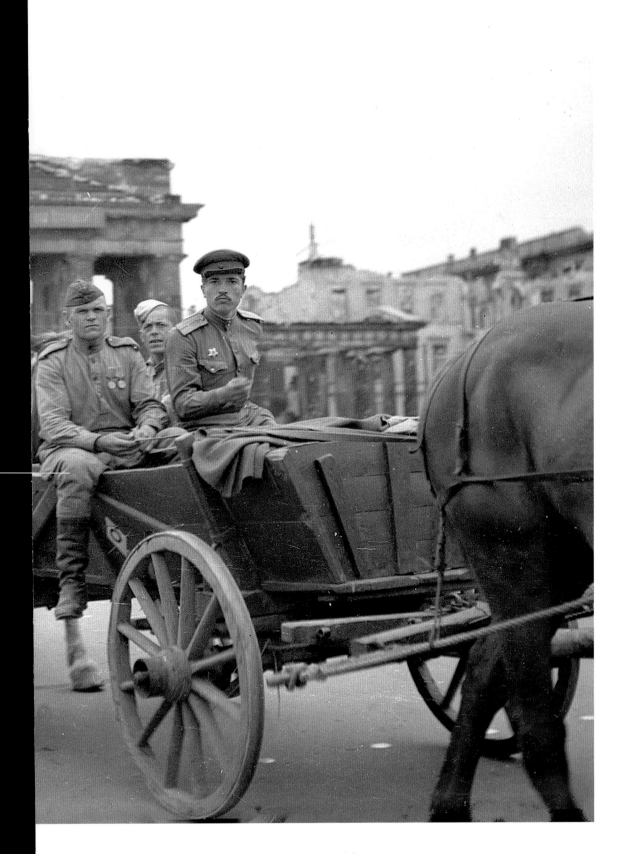

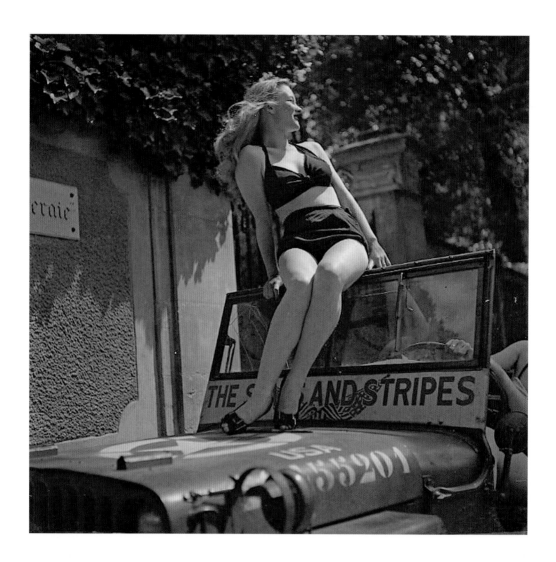

One more post war assignment as a photographer was to photograph a bevy of attractive USO girls residing in a Paris suburban villa. The young lady perched atop the windshield of the *Stars & Stripes* jeep is June Bright, a Hollywood starlet.

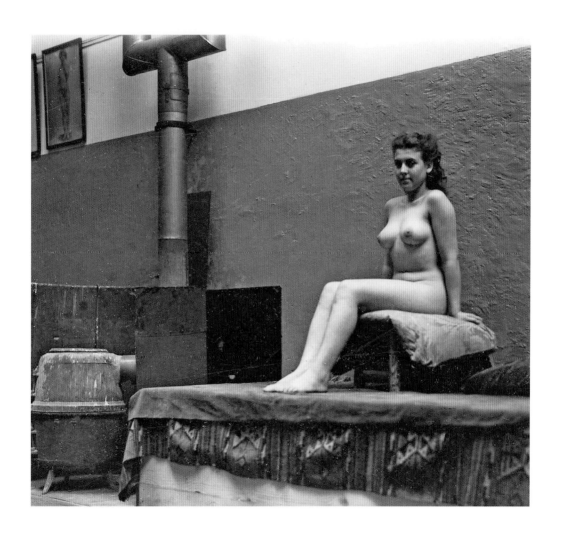

A nude model posing in a post war life drawing class at the famous Beaux Arts School in Paris.
The only heat from an ancient, coal-burning stove next to the model. December 1945.

The War's End

The heavily bombed ground floor of the Reichstag building. The well-known Russian journalist Svetlagorsk is interviewing a refugee. The far wall flanks Hitler's underground bunker, which was dark, and I unfortunately didn't have a flashlight when I visited. The steps going down were full of broken masonry. Unfortunately, it would have been impossible to see or record anything. Note all the "scratched in" Russian signatures on the stone walls and columns to record that "they were there." Berlin, 1945.

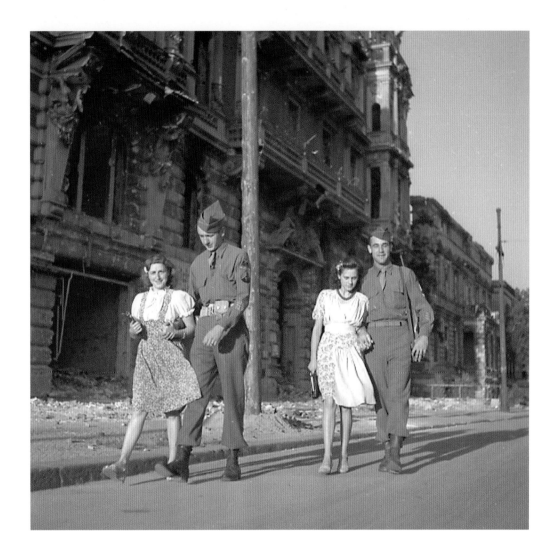

GIs fraternizing with two young German *frauleins* on some of the streets of Berlin. Most of the female population of Berlin had fled southward to Bavaria to escape the Russian onslaught.

The War's End

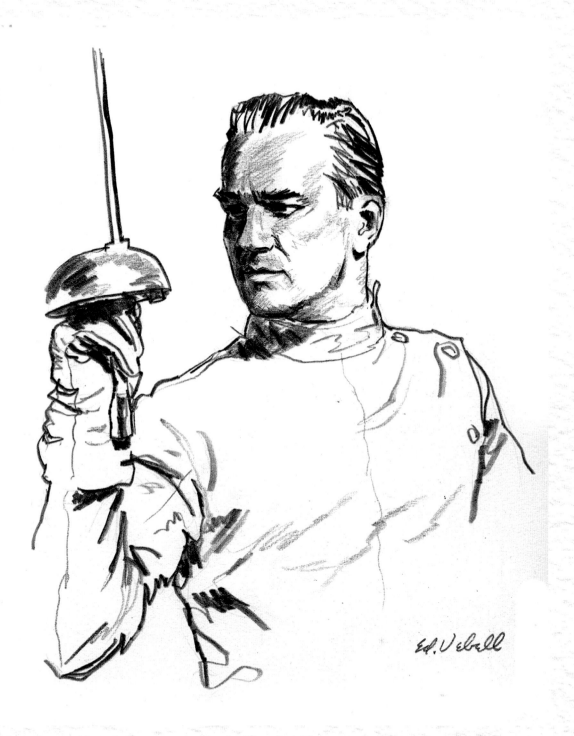

Self portrait of the author in 1952. This same year I made the épée semi-final round of the 1952 Olympics in Helsinki, Finland, topping it off by being the only American to win the gold in the épée International Challenge in 1962 (World Cup).

HOME AGAIN

RETURNING HOME

So many from the staff of *Stars & Stripes* and *Yank* resumed their pre-war and new positions on newspapers scattered across the US: Howard Brodie to the *San Francisco Chronicle*; Herb Mitgang and Jack Raymond to the *NY Times*; Marty Harris went to *PM* magazine; Lou Cortese to *Il Messagero* of Rome, Italy; Nelson Gruppo to *This Week* magazine; Dave Golding to Goldwyn Productions; Irv Levinson to Stuyvesant Press; and Ralph Martin writing bestseller biographies of famous personalities such as Golda Mier, Charles de Gaulle, and Winston Churchill's mother "Jennie," which became a successful TV series. Andy Rooney became famous as a personality on the "60 Minutes" CBS Sunday Show. Bill Mauldin, with two Pulitzer prizes under his belt, continued his political cartooning for the *St. Louis Post-Dispatch* and the *Chicago Sun-Times*. Stanley Meltzoff painted numerous covers for Scientific American, and became a painting instructor at Columbia University, to mention a few of the 500 or so on the staff of *Stars & Stripes* and *Yank*.

A year and a half rolled by since the war in Europe had ended, and I was now living a new life as a successful civilian artist in Paris. The year 1947 arrived, and I found myself working eleven and twelve hours a day, as my work was increasingly in demand. I had to make a decision to stay permanently in France or go back to the States and pick up where I had left off. It was a difficult decision to leave Lysiane, and it still haunts me today. My rationale was that I didn't feel she would have fit in to a new life in America. She didn't speak a word of English and seemed to be uncomfortable around Americans. For years after I came home, I dreamed of her knocking on my door, with me responding. There she stands with a gun in her hand, and fires a bullet to my stomach in revenge. The nightmare replayed for years! I always woke up in a guilty sweat! My conscience still bothers me to this day! Did I make the right decision?

Starting a New Life in New York City

By 1947, a few familiar faces started to filter back to Paris, looking to start new careers, mostly in illustration and cartooning after hearing of my success working for French publications. However, with my mind made up, I purchased passage on the *Gripsholm* leaving Goteborg, Sweden, and arriving in New York City after a five-day trip. I quickly found a small apartment/studio on East 40th St., and started a new flourishing career for the next forty-five years. As my work expanded I needed more room, which resulted in a five-room penthouse with a huge terrace surrounded by a screen of tall shrubbery for privacy.

My first major account was for the *Sunday Mirror* supplement magazine, which called for a weekly double page spread two-color illustration. This would be a feature story, but always with a very pretty, sexy young lady depicted. I was immersed in the Golden Age of illustration, which stretched roughly from the years just after the turn of the century to the late 1990s. Its heyday was primarily from the 1930s and was faltering by the late 1980s.

It was an exciting time to be an illustrator and to have the ability to recreate an unimaginable variety of scenes from life, transfer it to a drawing board, and be well-paid for the published result. There was always the added bonus for a young man to have to hire beautiful professional models to pose for the illustrations.

Of the hundreds and hundreds of models I hired, one stood out; Grace Kelly, who had a short modeling career in New York, when she was about eighteen years old in 1949. It only lasted about a year and a half, before she went on to Hollywood. Her face photographed beautifully from every angle. Each time she arrived at my studio for a modeling job, I couldn't resist asking her to go out for a dinner date, and each time with a polite refusal. I tried hard, but couldn't make out! I rationalized that the models were told not to go out with the artists and photographers. So much for an up-and-coming young bachelor artist with a large New York penthouse, plus an apartment in Paris, and soon to be Olympian, where I met her brother. He was on the US Olympic rowing team in 1952, as I was on the US Olympic fencing team the same year.

Only eighteen negatives, and one original illustration of Grace Kelly survived of her year as a model, but they all still look great! A year and a half had passed since I had resumed my interrupted career of freelance illustration for most of the New York publishing houses. At that period most of my work came from *Life* magazine, *Sports Illustrated,* and *Readers Digest.* The latter becoming a marathon of work for more than twenty-seven years.

The *Seaflower* Saga

I was still feeling adventurous, so soon after World War II, I saw an ad in a newspaper advertising a holiday trip to Bermuda, aboard a two-masted, seventy-foot wooden schooner named the *Seaflower.* We would be leaving from City Island on Palm Sunday that April, and using the schooner as our hotel on arrival in Bermuda. All this for the bargain price of $262! I signed on, and this became one of my most harrowing adventures of my life.

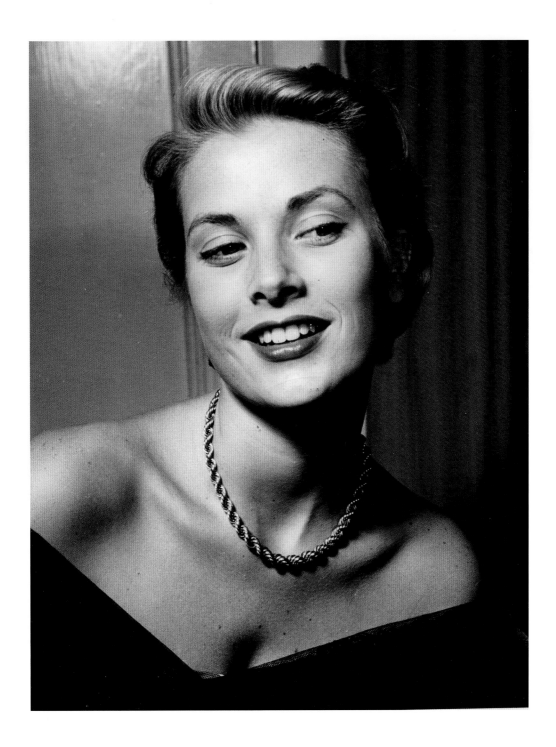

An unknown photograph of Grace Kelly posing for me as an eighteen-year-old model in New York in 1949, for one of my weekly illustrations for the *Sunday Mirror* magazine. She only worked as a model in New York for a year before she left for Hollywood and a new career.

Home Again

The *Seaflower* was a two-masted, sturdy wooden windjammer of Norwegian origin, and had been built to withstand the cold northern seas, and had been a blockade-runner in Norway during the Nazi occupation. The passengers that also came aboard totaled nine including myself, plus a skipper and a cook. Howard Cagle, a burly man, was our skipper, who turned out to have had only an engineer license, but he had been on a previous Bermuda run. The passengers and so called "crew" consisted of three men and four women. The ship's company was John Pitcairn, whose father was the president of the Autogiro Co. of America, and John's new bride Virginia. The other male crewman was John Knipper, an ample girthed stockbroker from Wall St. The other three women were Maybelle Bensen of Caldwell, New Jersey, Ruth Hanna of Rockville Center, Long Island, and Helen Petera of Schenectady, New York. Our cook, Bror Stolpe, a veteran at sea, later claimed that this was his worst sea experience ever.

We had one dry run in City Island Harbor on a beautiful sunny day before we shipped out, and mostly ran on the motor for a turn in the tranquil harbor. I was almost a complete novice at sea, but eager to learn. I didn't realize at the time that everyone else aboard, except for Howard Cagle, had no, or very limited, sailing experience. I had come with a small handbook titled *How to Sail*, with the hopes of learning on the job. The realization came later, that we had shipped out without a radio or transmitting gear of any kind, except for a hand held 1920s musician's megaphone.

The first two days were sunny with calm seas, and we watched the sun go down while we had cocktails topside. Then came the third night, and I had retired to my bunk below. About eleven o'clock in the evening I was awakened by the sound of rushing water two inches from my ear. I found myself lying on the sideboards of the craft instead of my bunk, due to the extreme heeling over on its port side. I thought something was amiss, and quickly dressed, taking the precaution to include my life jacket, and started to go topside. At the same time I noticed Virginia Pitcairn right behind me dressed in a cold weather jacket, but no life jacket. The scene that burst into view as I came topside, I will never forget!

The gale force wind was howling. I could just barely make out the almost invisible figure of Howard Cagle trying to stay on course at the large wooden wheel. It looked like something out of a vintage sea movie. On seeing me emerge on deck through the charthouse cabin, and shouting over the noise of the storm, "Boy, we're making good time!" I looked up at our rigging, and saw that he had left every inch of sail on the two masts, including a balloon spinnaker! The *Seaflower* was traveling like an express train, and heeled over her port side at a very dangerous angle. A few seconds later, Cagle yelled out, " we better start taking the sails down." It was pitch dark, and you would have to feel your way in the gale.

My job was to climb on top of the chart house, and reach up to try to start pulling down the mainsail; John Pitcairn went forward to see if he could pull in the foresail. His wife Virginia, who had followed me topside, offered to help me gather in whatever canvas I could pull down from the mainmast. She sat on the heaving deck with her back braced against the charthouse and her feet against the low railing, which surrounded

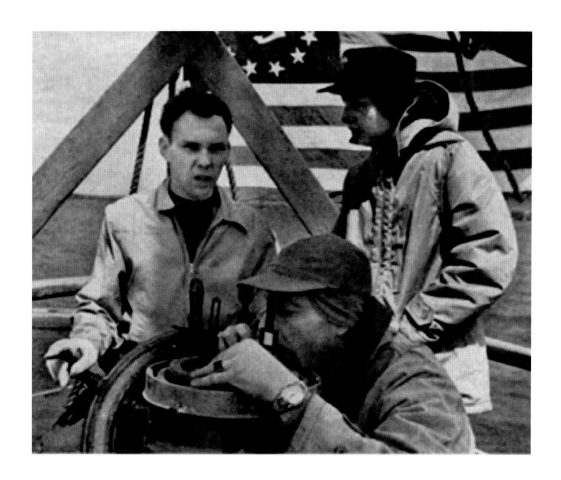

John Pitcairn at the helm and his new bride Virginia, taken on the first day of the ill fated eleven day run to Bermuda. Howard Cagle, the skipper, is taking measurements before the storm.

Home Again

the deck. But with the powerful wind keeping the *Seaflower* streaking through the water, and heeled over at a forty-five-degree angle, Virginia's feet were pointed straight down to the sea. With the seventy-mile-per-hour gale winds filling the sails, I could only pull down about four feet of the sail to hand to Virginia. In the darkness, I could just make out her hands reaching up to me to gather in the canvas. I sensed a slight motion and she was gone! Her feet had slipped off the railing and into the heaving sea without a sound from her. Aft of the wheel, Cagle saw a shape fly by, and yelled out, "Man Overboard!" I answered that it was Virginia! Her husband, John, who had been futilely attempting to bring in the foresail, heard the commotion aft, and was informed that his wife had slipped overboard! With cries of anguish, John tried to jump overboard to search for her in the raging sea. We immediately had to jump on him to hold him down, as we would have surely lost him as well. Cagle assured him that we would turn the boat about and search for her. But first we had the impossible task of bringing in the sails, which were under tremendous pressure from the wind. My emergency solution was to use the small bowie knife I had strapped to my belt, and slash the rigging to stop the boat. With one hand on the rail for safety's sake I managed to work my way around, cutting all the lines as I went. The impressive result was of all the sails reversing their direction, with the sound like cannon fire, and starting to shred from the force of the wind. But the maneuver worked, and the *Seaflower* was wallowing helplessly broadside to the wind and sea.

Cagle got the engine started and we turned the boat around and started to search the seas with a searchlight. I knew it would be futile, as by now, due to the force of the gale, we must have been driven miles from where Virginia had slipped into the sea. We searched all night, and into the early morning, but to no avail. She had donned a heavy coat to come up on deck, as it was cold, and neglected to put on her life jacket, but in those seas it would not have helped!

Then about 6:00 a.m. I heard the ominous cry of "Fire" from below. Rushing down the companionway, I saw the engine on fire from overheating! The only possible remedy was a bucket of sand nearby, which was tossed on the engine to douse the flames. Now we were really in trouble! We were caught in the middle of this gale, driving us northward, with no control of the craft, just wallowing broadside in the high seas. That same morning Cagle gathered us all together on the heaving deck to make an announcement which read like this: "I want you all to bear witness that I had turned the boat around to search for Mrs. Pitcairn, but to no avail, and I can do no more." With that statement, he took a bottle of bourbon and retired to his cabin. John Pitcairn, the only other man with some sailing experience, understandably retired to his cabin in grief, also with a bottle of whiskey. Both disappeared for three days and left the helpless *Seaflower* in the hands of two ignorant seamen: John Knipper and myself.

Neither of us knew what to do. We hunkered down in the charthouse, as it was too dangerous to stand upright on the wildly pitching deck, and watched the unmanned wheel spinning first one way and then the other way. I thought I had to somehow get to the wheel and use myself as a lookout, hopefully for a passing ship. I had been pretty

skillful with a lariat, growing up in the prairies of Chicago. I was able to throw a loop over the spinning wheel and haul myself hand over hand to my target. This gave us two landlubbers, a safety line from the wheel to the charthouse, and below deck. We took turns lashing ourselves to the wheel to scan the horizon between the huge waves. It was like a never ending roller coaster ride, stretching around forty feet from the bottom of the trough of the wave to its crest. This went on and on, day after day, with no sleep. The topside hatches were smashed, with water coming in. The downed ripped and ignored canvas sails were laying at crazy angles across the pitching deck.

Helen Petera, the schoolteacher, lay stiff with fright on her back at the bottom of the ladder, not moving, but with her eyes wide open. I thought it best to leave her alone; if the ship went down, better that she might not know about it. So we just stepped over her prostrated body. We rarely went below since the large 500-pound spindle table in the dining area was ripped out of its moorings, floorboards and all, and was crashing into the sidewalls of the hull. It was acting like a battering ram! I thought for sure it would punch a hole through the sides, and we would all go down in this manner. Also not a pleasant prospect! Sleep was impossible. I tried once to crawl into my bunk, but a very frightened Ruth Hanna crawled into my bunk as well, seeking some comfort and assurance that we will be saved. I didn't want to admit that I was just as scared as she was. I hoped I had convinced her that all will be well, and surely a passing ship will see us.

Knipper and I spent the next three days alternating between the charthouse and our lookout position at the wheel, all the while being driven further northward, still caught in the middle of the storm. Still no sleep. I had the perverse thought that I wanted to be awake when the *Seaflower* went down. I remembered a lot of my boyhood prayers. I promised the moon.

After three days, Cagle suddenly reappeared from his cabin looking the worse for wear, and announced we should all pitch in and try to save the ship. John Pitcairn had come up on deck at the same time. The force of the wind had abated somewhat, so it became possible to stand on the deck unassisted. The idea was to gather up all the torn canvas lying on the deck and start to sew the largest pieces together to hopefully make a new sail. It was therapeutic, and gave us something to do, as well as some hope. After a day of sewing, we hoisted the repaired sail, only to see the still too powerful wind reduce our hard work to tatters.

During the very early morning of the ninth day, with the seas calming down, I was at my position as lookout at the wheel. I spotted a thin column of smoke on the distant horizon. I alerted the three men from below, which started a frenzy of signals, such as hoisting the American flag upside down, then burning oily rags in a bucket to make smoke, none of which had any positive reaction. All the while the smoke on the horizon kept appearing fainter. I suddenly thought of the large mirror on the wall of the companionway. I told Knipper to quickly get it off the wall, climb up the rigging, and just flash the mirror repeatedly in hopes that someone will see the flashing. After a few minutes, sure enough, we could see the smoke slowly turning and getting larger. Jubilation! We were about to be saved!

The freighter *Oceanic* was on its way to Le Havre, pulled up alongside, and its skipper queried our problem. Cagle, via a small megaphone, related our predicament and the loss of one girl aboard. The freighter captain in turn radioed this information back to the US Coast Guard and added help would be coming in a day. That afternoon, a Coast Guard rescue airplane came into view, circled overhead a few times, then dropped two large inflatable life rafts near our drifting vessel; but we had no means to retrieve them. So they soon disappeared from view over the horizon, reinforcing our feeling of helplessness.

By the end of the day, we finally sighted our "Knight on a White Horse." Which was a white Coast Guard cutter bearing down on us under full steam. They pulled alongside the *Seaflower* and offered their help. We all thought we would be transferred to the safety of the cutter, but Cagle refused their help. He felt that we could all pitch in again to repair the remaining canvas and make it back to port by ourselves. He asked the cutter to stand off about a quarter mile, as an emergency safety measure, but keep us in view. We were all disappointed, but had no choice, and took to sewing up the odd pieces of sail, plus pumping out the accumulating water in the bilge, due in most part from the smashed in transoms on the deck. The chore of hand pumping out the bilge water was relegated to Knipper and myself. It's an up and down see-saw action, and after a few minutes of pumping Knipper yelled "lookout" and I ducked down, just in time for the huge main boom to silently swing from starboard to port, at the height of my head, with no warning. I turned to see Cagle at the wheel, which had just tacked, grinning at me. He was hoping to knock me overboard, for showing my displeasure with his handling of the affair. We faced off briefly on the deck, like two bulls ready to fight, but he was the so-called "captain of the ship." After a lot of glaring (I can't remember who broke the tension), I decided to back off. Probably because we still needed an authority figure and I was not a sailor. We repaired the sails, but again they shredded.

At dawn on the eleventh day came the *coup de grace*, like a cannon firing the last shot of a war. We heard a very loud "crack" and the main boom split with water gushing from the break! It was the last straw, and Howard Cagle finally admitted defeat, after battling the high seas for eleven days.

He was able to signal the watchful Coast Guard to pull alongside, and after a brief conversation the Coast Guard fired a cannon, which shot a line between our two masts. We secured the line to our foremast and started our long tow back to the nearest port in the US, which happened to be Greenport, Long Island. By the time we started our return trip, I believe we had drifted near to the latitude of Nantucket. Quite a long way from Bermuda!

When we berthed at Greenport, two agents from the FBI greeted us on the dock; the result of the freighter *Oceanic* radioing that there had been the loss of a female passenger on the *Seaflower*, but neglecting to name the victim. With two prominent names aboard, it made a stir. As soon as we docked, I opted to leave, to try to forget my sea adventure. Howard Cagle was prosecuted in a New York court, but he was let

off leniently. I saw him briefly walking towards me on 50th St. in New York a few weeks after the trial. We nodded our heads in acknowledgement and passed each other like two ships at sea. However, one favorable result of the trial was that the New York Port Authority passed a law named after our schooner *Seaflower* stating that the proper port authorities be notified when leaving the coast of America for the high seas.

John Pitcairn briefly stopped off at my studio on 40th St. to bid farewell. He had just purchased a single engine aircraft, and was about to fly to South America to try to forget and ease the pain of the loss of his wife. Later that summer, I was sitting on a beach in Nantucket painting a watercolor of a lighthouse, when I perceived a small eighteen-foot sailboat scudding along in the wind. It suddenly pulled up and proceeded to dock on the beach quite close to where I was seated. Lo and behold it was John Knipper! As he approached trudging through the sand, I called his name out in amazement. That our paths would cross again so soon after our recent debacle. His immediate comment was how much he had fallen in love with sailing. It was now his new passion! His waistline now looked trim and flat, as opposed to his ample girth when he boarded the *Seaflower*, as well as a new fresh cigar clenched in his mouth. The frayed beat up stump of a cigar, he perpetually had held on to for our eleven day trip, was finally retired. We exchanged news, parted company, and that was the last contact I had with our crew. My then girlfriend Elsa Cerra wondered why she had never received a post card set from Bermuda. So ended the saga of the *Seaflower*.

Note: Looking over the numerous newspaper articles written about our journey, many were quite devoid of the actual story unfolding. This was due to the newspapers only interviewing the two young ladies who had stayed below deck for most of the storm, and them claiming Howard Cagle as the hero who had saved the ship! My beef with him was his retiring to his cabin for three days with a bottle of bourbon during the height of the storm. After the loss of the young lady, I felt Cagle secretly hoped the *Seaflower* would go down, with the loss of everyone aboard. With that scenario, he wouldn't have to answer to anyone!

ILLUSTRATION CAREER

I now started a long, successful forty-two-year stretch of illustrating for most of the leading magazines in New York City. To name some of my principal clients: *Readers Digest, Sports Illustrated, Life, The Sunday Mirror, Time, This Week, Tennis, Sports Afield,* and *Skiing*.

Using my newfound penthouse on West End Ave. as my studio, I photographed a weekly bevy of beautiful professional models for my story illustrations. Starting back in the late 1940s and early 1950s, the modeling agencies charged only $25 an hour to artists, as the working conditions for the models were easier. Many future movie stars of that period got their start as New York models before their cinematic careers: Grace Kelly, Mariette Hartley, and Michael Douglas to name a few. I still have their photos.

FENCING CAREER

Parallel to my art career, my training in fencing continued unabated, starting with the New York Athletic Club under Georgio Santelli, the famous fencing coach. There, during a fencing tournament, I met Maria Cerra, who had taken fourth place in the women's foil in the 1948 London Olympics. At the same time, seated next to her was her sister Elsa, a Spanish looking beauty, who two years later became my wife.

The wedding ceremony took place at the NY Fencer's Club. We were ushered into the Fencer's Club, under the crossed sabers of the entire Olympic Fencing Team. Naturally, I was handed an antique, but sharp dueling saber to cut the huge wedding cake. Our honeymoon was divided between visiting Elsa's Spanish relatives in Madrid, and later on to Paris. The man of the house in Madrid, coincidently, also turned out to be an Olympian, but represented Spain as an equestrian. That made a total of three Olympians in the family. Journing on to Paris, and staying at my old apartment, which was still open to me and my new wife with no charge. The honeymoon went on for a month and a half.

Elsa fenced quite well, but not in the same class as her sister. I shifted my training to the New York Fencer's Club under Rene Pinchart, a top flight Belgian fencing master, also because that was where the Cerra girls trained.

One interesting episode occurred when Ed Sullivan requested a fencing demonstration from the NY Fencer's Club to be aired on his eagerly watched Sunday evening show. The demonstration featured my attractive new wife taking a fencing lesson from Rene Pinchart, followed by bouts by the Fencer's Club Olympic team members. Paul Gallico, the famous sports writer, also participated. He gained notoriety by getting in the ring with Jack Dempsey to get a feel for how it feels to be hit by the "Manassas Mauler." He loved fencing and tried very hard, but had to be carried by the scoring of the rest of the team members.

As a result of the training I received at the hands of Rene Pinchart, and in competitions won, including taking third place in the National épée Finals of 1952, I garnered a place on the épée Team for the 1952 Olympics in Helsinki, Finland. I did well for an American fencer in his first Olympics by reaching the semi-finals, a rarity in those days.

A couple of days later, the handicap under which I had been training was spelled out to me by the Olympic Champion himself, Edoardo Mangiarotti. We were all alone, seated in the Olympic bus, with no one within earshot. He started by saying, "you Americans are stupid, because you are all amateurs, along with the British and the Australians. We Europeans are all professionals." He told me how each industry in Europe is assigned to take care of a designated sport financially. The athlete's names are carried in their ledgers, as if they work for the company and they receive a good salary with perks. But instead of working at the company job, they could train every day and compete on weekends. Fiat Motor Company took care of the Italian fencing team for example. All I could think of at the moment was, if I could only train with that intensity, and be free of any financial pressures, then I too could have been in the Olympic finals!

Since the inception of the Olympic Games the paramount rule was that the athletes were to be unquestionably amateurs. The Europeans, Asians, and South Americans blatantly ignored this stipulation in 1952. I have often wondered if I had gone public with Edoardo Mangiarotti's private confession, would all of the medalists in the Olympic fencing tournament finals be obligated to return their medals? That would mean that every other competitor would move up in rank; but the problem of professionalism would still remain throughout the Olympics. I decided to remain quiet about Mangiarotti's confession; anyway it probably would have been denied as ever having taken place.

The sport of fencing has always been considered a safe sport and usually devoid of serious injuries, but there have been exceptions. Mine came at the climax of a championship match with my teammate Al Skrobisch from the NY Fencer's Club. We both scored a series of double touches that awarded neither of us a victory. My worthy opponent's épée blade broke but with still a final double touch, and now with a very sharp steel broken point, which entered my chest, causing my collapse to the floor. The memory of the blade protruding from my chest, and the horrified look on the face of my opponent I will never forget! He truly thought he had killed me! I thought so too. But the blade missed my lungs and I recovered quickly, after a short stay in the hospital. The victor in that particular épée tournament was never determined.

The épée/fencing bout in the semi-final round between myself and Marcel Bougnol (Champion of France) in the 1952 Olympics held in Helsinki, Finland. The author was the victor.

Home Again

Winning Gold, Silver, and Bronze

However, in the 1951 Pan-American Games in Argentina, I garnered gold, silver, and bronze medals in both foil and épée. In the 1953 North-American Championships in Toronto, Canada, I took first place in foil and second place in épée. Again in 1956, I earned my place to represent the US on the Olympic épée team. Unfortunately, a week before we were to board the plane to Melbourne, Australia, I suffered a detached retina, while I was straining my eyes to sketch the defendants during the *Andrea Doria* trials for *Life* magazine. A great disappointment, but I had a fairly quick recovery and continued to place either first or second in all the NY Metropolitan tournaments for the next four years.

I was told I was in first place to go to the 1960 Rome Olympics, but unfortunately, the night before the last qualifying tournament for the Olympics held in New York City, I had to take my wife to the hospital for a serious procedure. This resulted in standing on my feet all night with no sleep or rest. The following morning, I had to start at 9:00 a.m. in the preliminary rounds. I found myself so tired that I barely made it out of the preliminary round. I was dead on my feet for the quarter finals and was eliminated early for the first time in my fencing career. As a result, I was dropped from first place to seventh, and there were only six berths to go to the Olympics. All I had needed was a night's sleep, and it would have been a different story.

My next major victory was winning the International Épée Challenge in 1964, now referred to as The World Cup, held yearly at the NY Athletic Club. It is considered a World's Championship, but of secondary importance, since sometimes a European country fails to show up, such as Russia. I have the distinction of being the only American to have ever won this competition. I was forty-three years old at the time, and then shifted my competitive years to the state of Connecticut, where I lived and worked. With my Yale Hospital head nurse wife Elsa, and my three daughters, Vicki the artist, Renee the teaching nurse, and Andra the playwright, we lived on the beach of Westport, Connecticut.

My fencing life culminated in being elected recently to the US Fencing "Hall of Fame." I had a good run!

One Further Adventure

Once more lady luck came to my rescue, when on a business trip to West Virginia in 1954. I received a lucrative commission to illustrate the results of a one-day's production of the entire West Virginia Paper and Pulp Co. in one large illustration. I was picked up from Westchester airport in the company's private four-passenger single propeller airplane of questionable vintage. The trip to West Virginia was uneventful. After three days, my photography and research was completed and I boarded the same airplane with the same rather elderly pilot. Again, I was the only passenger for the return trip to Westchester airport. The weather started out very gray and cloudy with hints of rain.

Approaching the Appalachians, the weather and clouds closed in on us with torrents of rain and lightning! Our vision was down to zero with the plane bouncing helplessly

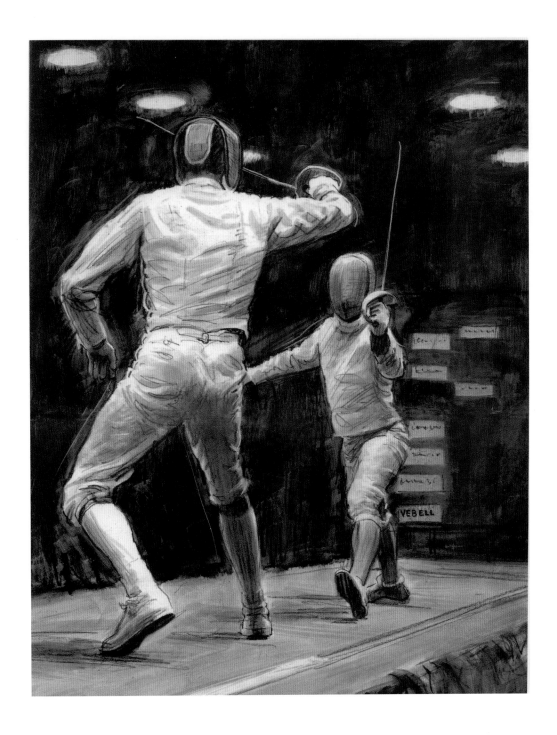

A drawing I did of a saber bout at the New York Athletic Club in 1967, for a program cover. Judging from their style, I would say they were European contestants. My saber skills were not as strong as my foil and épée, but I still managed to win the Metropolitan 3 Weapon Championship in New York in the 1960s.

Home Again

from the force of the storm. I don't remember praying for salvation, but I now had the most bizarre experience! Seated behind the pilot with my face close to the right side window, a small hole opened up in the clouds about three feet in diameter and about forty feet from the wing tip. In the hole was the top half of a man smiling and waving to me! A second later the man was gone! The only reasonable explanation was that we had narrowly missed a park ranger's lookout station on top of the Appalachian Mountains. The pilot never saw him, but a few seconds later the pilot announced that he could go no further, and would have to make a forced landing somewhere. He told me he had been an experienced barnstorming pilot in the 1920s, and delivered airmail from an open cockpit. In a situation of poor or no visibility, the pilots would have to spiral downwards, until hopefully they saw the tops of telephone wires, signaling they were close to the ground and to pull up. His next words were for me to hang on tight as we spiraled downwards. Lady luck was still with me for the sixth time. A flat farm field appeared out of nowhere. The pilot was able to pull the plane out of its dive and land safely. I lived to tell the tale. A harrowing and unforgettable trip!

A post war illustration recreating the D-Day landings at Omaha Beach, Normandy by American troops on June 6, 1944. All the equipment used was original and the beach was Compo Beach, Westport, Connecticut.

G.I.'s watching movie
in occupied Germany

Home Again

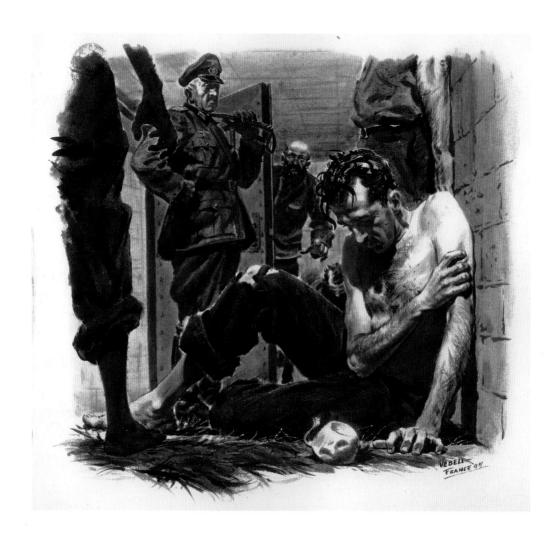

Illustration of a German prison camp for an unknown magazine. This was done while I was in France in 1944–45. I would occasionally receive articles to illustrate from stateside magazines.

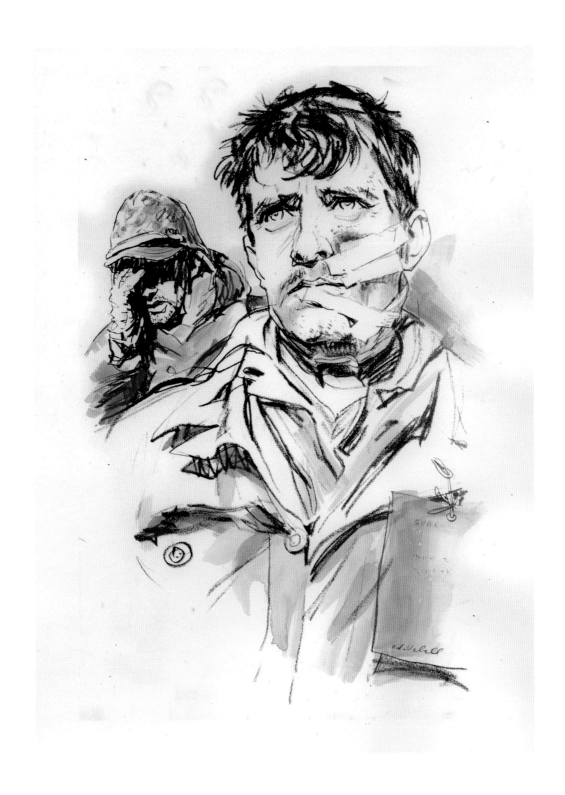

Scene of walking wounded in cold winter muddy mountains at a crude makeshift medic station, Monte Cassino, Italy. Done from memory.

Home Again

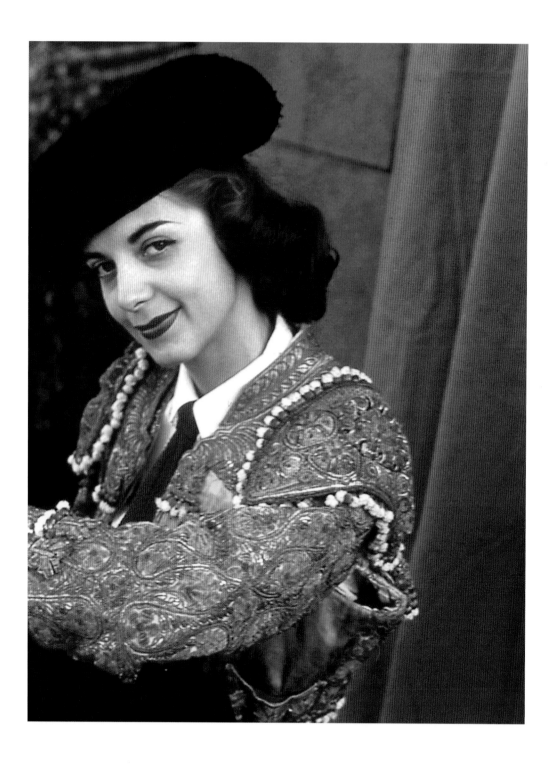

My wife, Elsa Cerra, posing in a Spanish Matador's original "suit of lights," purchased in 1950 on our honeymoon in Madrid. The trip also included a visit to her Spanish relatives, one of whom was on the Spanish 1948 Olympic equestrian team in London. Her sister, Maria Cerra Tishman was also on the American Olympic fencing team, placing fourth in the foil. There were a grand total of three Olympians in the family!

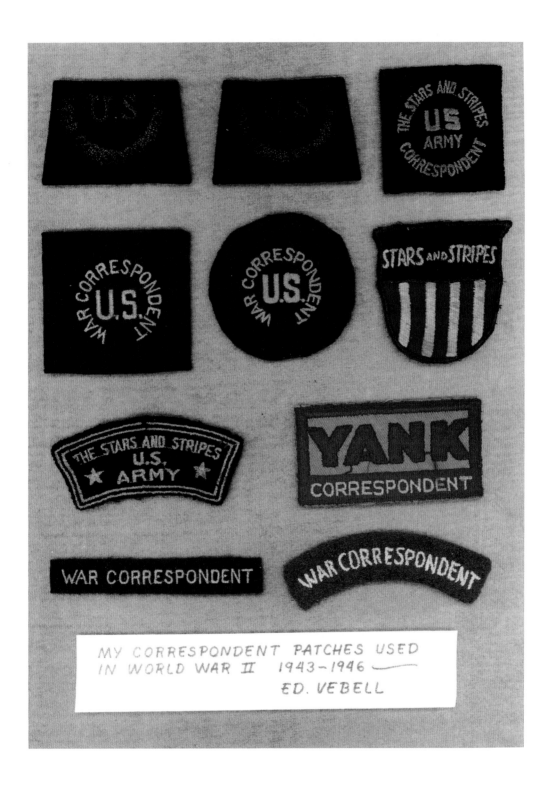

MY CORRESPONDENT PATCHES USED
IN WORLD WAR II 1943-1946
ED. VEBELL

My *Stars & Stripes* identification insignia worn throughout the war. I include the *Yank* insignia as I have a dual membership with both publications as a reward for the amount of work I did for *Yank*. Andy Rooney also had the same dual role.

Home Again

After the closing down of *Stars & Stripes*, I transferred my illustration skills to the nacent French publications springing up in Paris. This illustration show a lost US paratrooper in the French countryside on D-Day, 1944.